WORCESTER
THROUGH TIME

FRANK MORRILL
& HANNAH MORRILL

AMERICA THROUGH TIME®

AMERICA THROUGH TIME is an imprint of Fonthill Media LLC

Fonthill Media LLC
www.fonthillmedia.com
office@fonthillmedia.com

First published 2013

ISBN 978-1-62545-069-2

Typeset in Mrs Eaves XL Serif Narrow
Printed and bound in England

Connect with us:
www.twitter.com/USAthroughtime
www.facebook.com/AmericaThroughTime

AMERICA THROUGH TIME® is a registered trademark of
Fonthill Media LLC

INTRODUCTION

Worcester, the 'Heart of the Commonwealth', began with a 1660s survey of the land around Lake Quinsigamond. What is today an ideal location in the center of the state, was in the seventeenth century far removed from commerce, transportation and populated areas. In a 1668 report to the Court it was decided to 'reserve it for a town'. After two unsuccessful attempts at settlement, Jonas Rice, in 1713, became Worcester's first permanent settler and by 1718 the population was two hundred. From this humble beginning Worcester steadily grew into a town with its associated structures. The railroad began here in 1835 and greatly changed the town's fortunes.

With industry moving more quickly, Worcester became a city in 1848. The next seventy-five years saw a continued and rapid industrial expansion that resulted in the city becoming a national leader in diversity of manufacturing. In fact, the city was home to such a myriad of manufacturing companies and products that the city became known as the largest inland manufacturing city in the United States. Most of this diverse group of companies were small to medium in size and employed less than 100. American Steel and Wire and Norton's, an abrasives manufacturer, were the two best examples of companies that exploded in growth and became among the largest in the nation.

It was surely this diverse industrial base that spurred the brisk population growth and the many changes to the residential and cultural landscape. Three deckers were beginning to line streets all around the city, so much so that Worcester became know as the city of three deckers. This growth necessitated the building of dozens of neighborhood schools and fire stations, many of which are still standing today. Worcester's many colleges, that today play a crucial and expansive role in the community, began to grow in number and draw on the increased population for students. Other important cultural changes accompanied this rapid growth. We now saw the building and expansion of the Worcester Art Museum, Lincoln Park, Bigelow's Garden amusements, White City amusements, and the development of the Oratorical Society just to name a few. Churches of all denominations to accommodate the diverse immigrant population were built throughout the city. Many of those architecturally significant structures remain to day. Today, Worcester has moved into a significant position in the biotech field and its population has continued to rise over the past decade reaching 181,045 in 2010.

ACKNOWLEDGMENTS

The vintage photographs in this book are primarily from Frank J. Morrill's glass negative collection and a collection of the *c.* 1900's photographer William Bullard. The color photographs showing the present day were all taken by the authors. A special thanks to Lenore Morrill for help in editing.

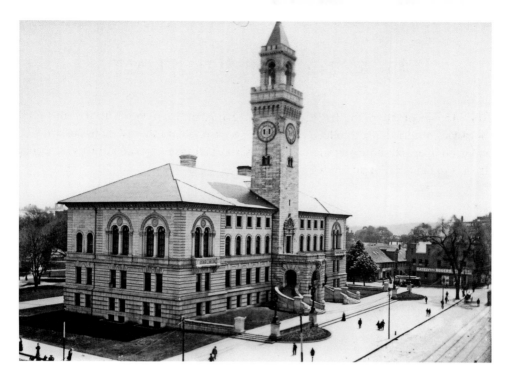

CITY HALL: The new City Hall, pictured above, replaced the original one that was on the left next to Front Street. The old City Hall was built as a Town Hall in 1825 and became City Hall in 1848 when Worcester incorporated as a city. The new building, designed by Peabody & Stearns, was dedicated on April 28, 1898. It occupies the site of the Old South Congregation Church and originally contained 60 rooms. At 285 feet wide it is an imposing sight on the Common. Below one can see the glass foyer of the Sovereign Bank tower at the corner of Main and Pleasant Street.

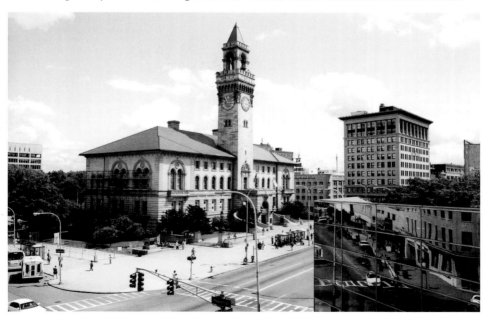

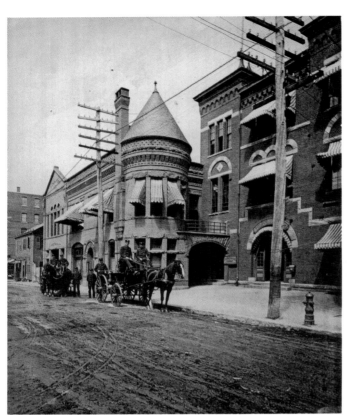

WALDO STREET POLICE STATION: The Waldo Street Police Station and Central District Court building shown above was built in 1885. This 1890s view illustrates the method of transportation that police used at the time. By 1910 the Chief of Police wrote the following in his annual report to the city, 'I recommended automobiles for use in the Police Department and do so recommend now, we have purchased no new horses, wagons or equipment'. Today the above building is gone and the 1918 replacement, now called One Exchange Place stands next to the parking lot behind Mechanics Hall.

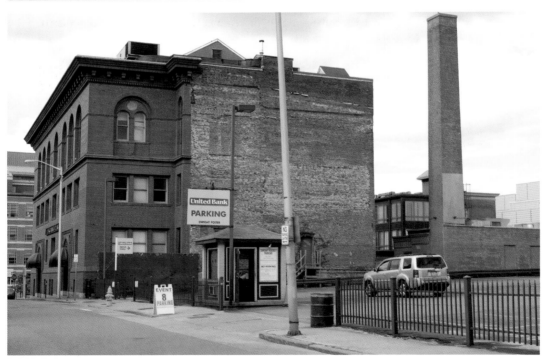

WEBSTER SQUARE FIRE STATION: The Webster Square Fire Station, built in 1893, was new in this late 1890s photograph looking down Webster Street toward Webster Square. The fire station can be seen in the center at the bottom of the hill. Webster Square School house, built in 1858 closed in 1933 and torn down in 1962 was located where the parking lot to the right of the station is today. The old station, originally home to teams of horses and old pumpers, was torn down in 1999, and replaced with a station with a similar façade. Below the twin towers of residential housing can be seen in Webster Square.

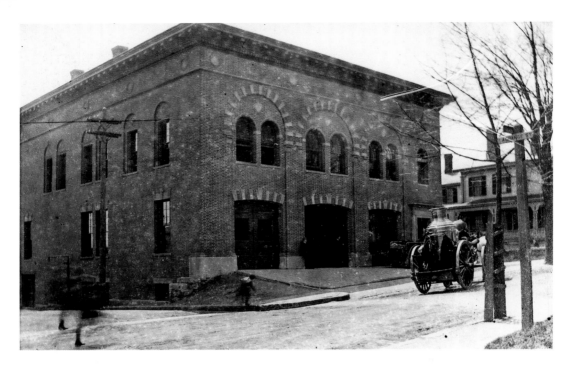

BEACON STREET FIRE STATION: The Beacon Street Fire Station can be seen in this *c.* 1900 photograph with its old fire pumper being pulled by horses. The blurry figures to the left are children excitedly running to see the horses and fire equipment. Below the station today is privately owned, and appears to be in excellent condition.

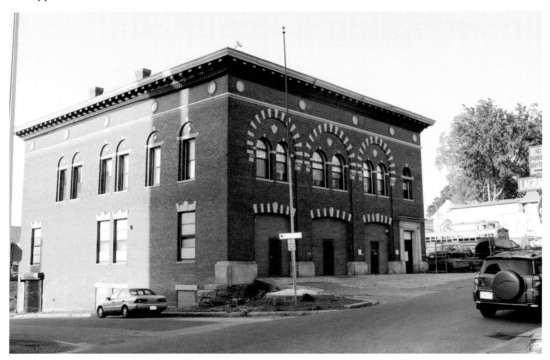

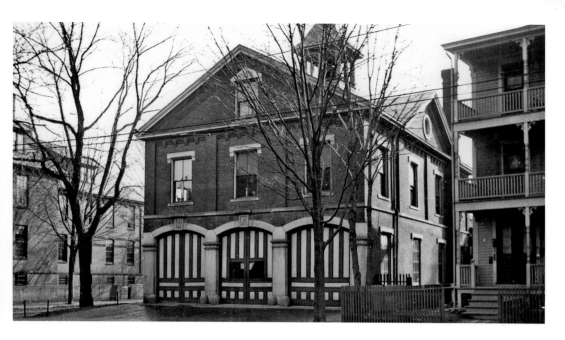

WINSLOW STREET FIRE STATION: The Winslow Street Fire Station, built in 1873, actually faces Pleasant Street. This view from the 1890s shows the graceful arch over each door that was replaced by straight lintels during a remodeling in 1951. It closed in 1979 and is now Ed Hyder's Mediterranean Market Place. The brass pole for firefighters to slide down was first used in Worcester in 1880 and one still remains in the market. The Winslow Street School to the left was first occupied on September 10, 1878 and was destroyed by fire 100 years later in 1978.

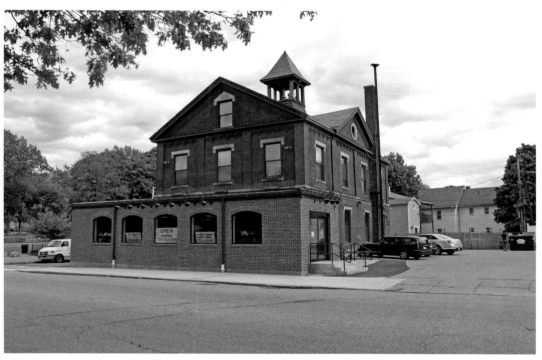

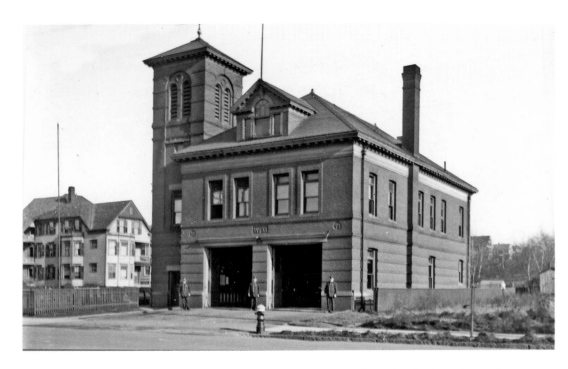

GREENDALE FIRE STATION: The Greendale Fire Station located on West Boylston Street, home to Engine 11 and Ladder 6, was demolished in 1973 and the new station seen below was built on the same site. The eight firefighters on duty at the time pose proudly in front of their station with the E11 and L6 above them.

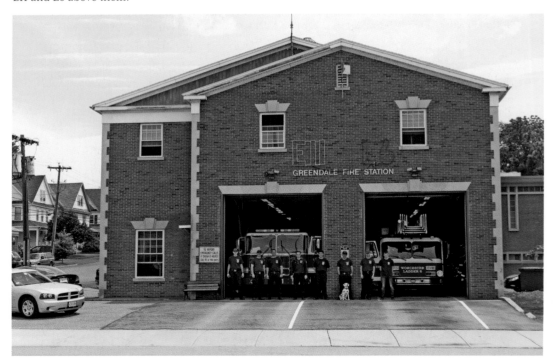

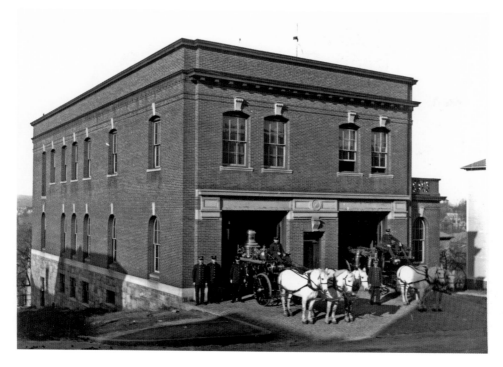

EASTERN AVENUE STATION: In this 1911 photograph of the Eastern Avenue Station the firefighters, horses and equipment strike a nostalgic pose from a bygone era. At the time of the photograph the Worcester Fire Department owned eighty-seven horses but technology was changing and by 1926 only one remained in service. The station today is a private residence. Its hilltop location off of Belmont Street affords the occupants a clear view of the city.

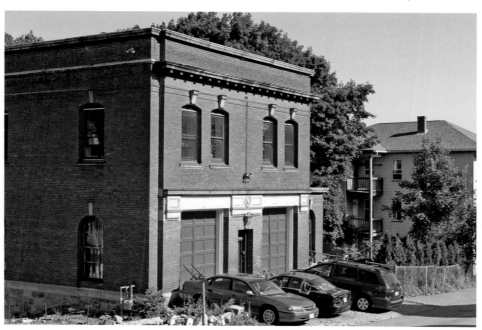

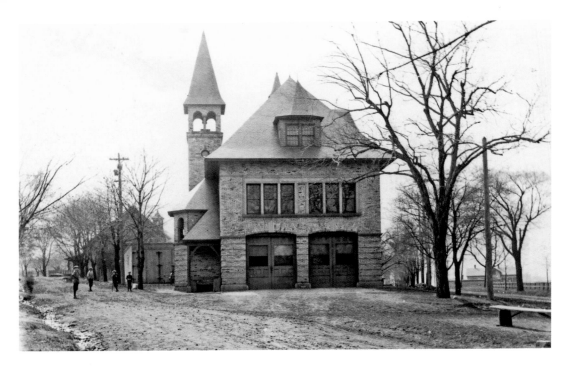

BLOOMINGDALE FIRE STATION: The Bloomingdale (Brown Square) Fire Station is at the intersection of Franklin and Plantation Streets. Constructed in 1894-5 for just $12,420 it remained in service for over 100 years and was recently closed. Its closing signaled the end of the nineteenth-century stations. It was called Bloomingdale Station because when built, the road to the right, Franklin Street, was then called Bloomingdale Road.

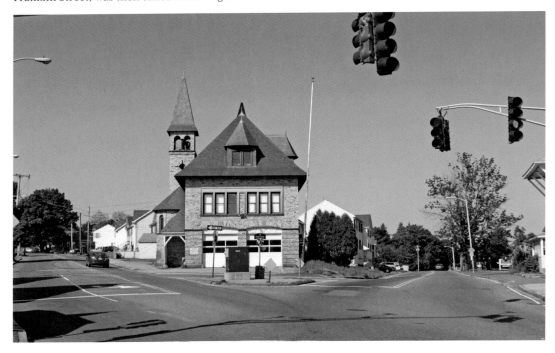

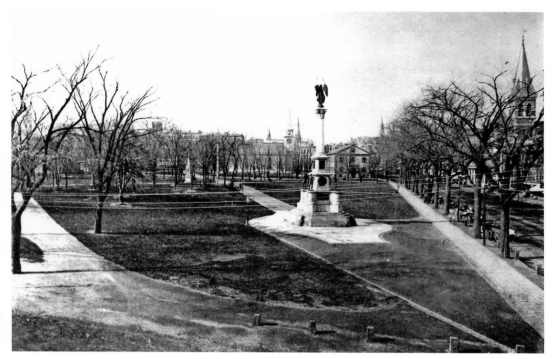

CITY HALL: This unique and rare 1880s view is looking across the Common at the back of the Old Worcester City Hall and to the left, the side of the Old South Congregational Church. That was built in 1763 and torn down in 1887. Isaiah Thomas first read the Declaration of Independence publicly on July 14, 1776 from its porch steps. The 65-foot Soldiers' Civil War statue was dedicated on July 15, 1874. The photograph below shows the dramatic change with the new City Hall and the Sovereign Bank Tower.

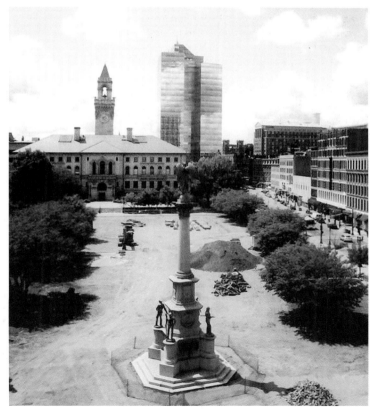

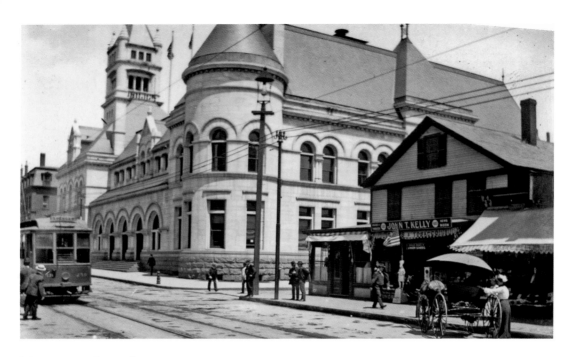

WORCESTER POST OFFICE: This 1912 view shows the Worcester Post Office, built in 1896 at the corner of Southbridge and Main Streets. This building was razed in 1930 and replaced with the building in the photograph below that is now the Federal Building. This view above shows the John T. Kelley Tobacco store at 603 Main Street now the Registry of Motor Vehicles. Above, the trolley is headed west to Spencer.

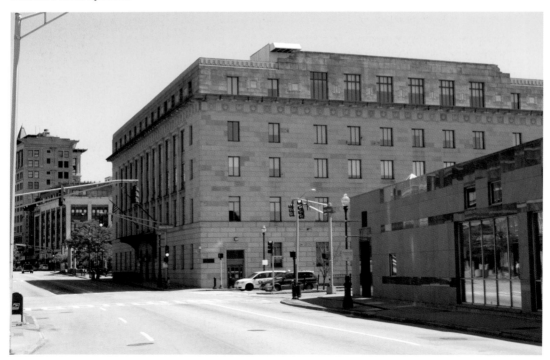

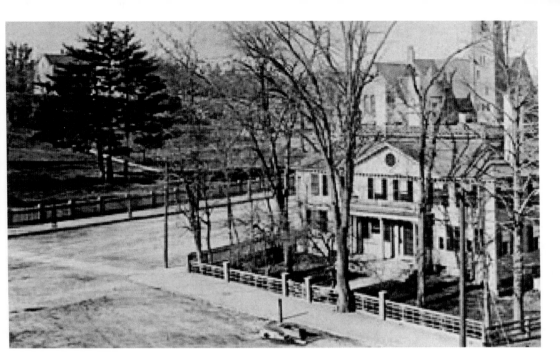

SALISBURY MANSION: This 1890s view is of the Salisbury Mansion, built by Stephen Salisbury I in 1772 at Lincoln Square. It served as a store and a residence. In 1929 it was moved to its present location at 40 Highland Street. Below, the Worcester Memorial Auditorium, which was built in 1933, has replaced the grassy knoll. Also below is the former Worcester Boys' Club that was built soon after the Salisbury Mansion was moved. This building was recently used by Worcester Voke before they moved to their expansive new school on Skyline drive.

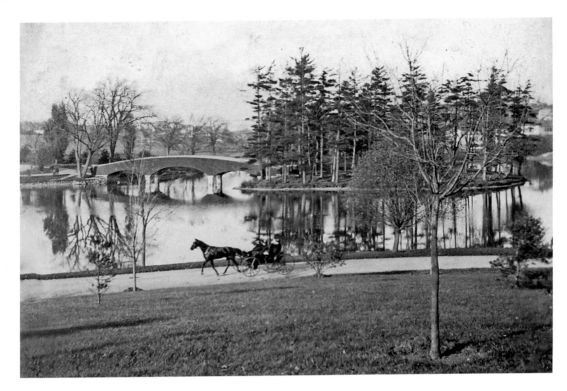

INSTITUTE PARK: This idyllic scene from the 1890s shows Institute Park on Salisbury Street across from Worcester Polytechnic Institute (WPI) when there was a bridge to the island. Stephen Salisbury III donated the 17 acres in 1887 and provided $50,000 to build the bridge, boathouse and other structures. Below on a warm spring day the park is still serene but the bridge is gone and the larger trees do not allow for the view above.

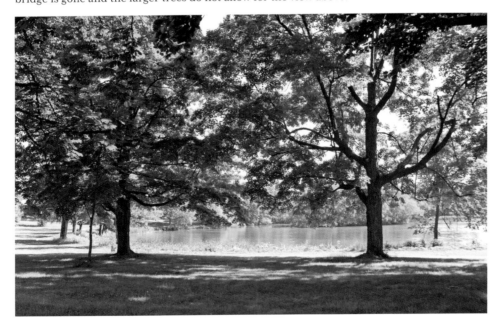

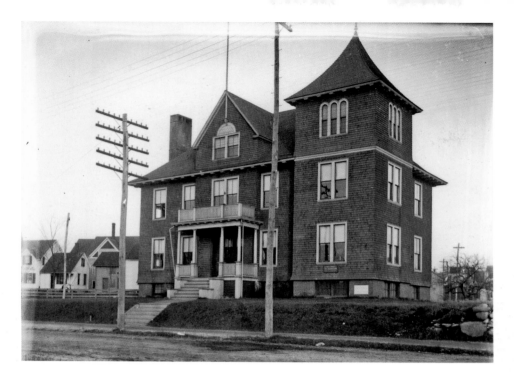

GREENDALE IMPROVEMENT SOCIETY: The Greendale Improvement Society was interested in improving the quality of life for the Greendale community by collecting trash, providing more greenery and assisting in fire protection. The building is located on 480 West Boylston Street at the corner of Airlie Street. Today, slightly remodeled, the building, as one of the signs in front states, is available for community rental for all occasions.

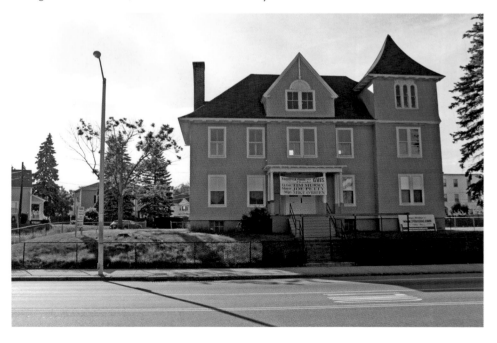

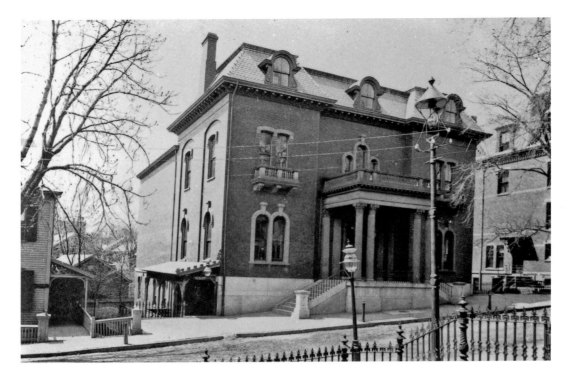

WORCESTER FREE PUBLIC LIBRARY: In the 1890s the Worcester Free Public Library was a strong focal point of the community. The access to books, learning and information was limited and the library was an oasis of information for the young and old. Located at 18 Elm Street this building was later greatly expanded and used until the 1960s. Today the Worcester Library is on Salem Street at the corner of Franklin. The Library above is now a multistory parking garage. Main Street is in the background.

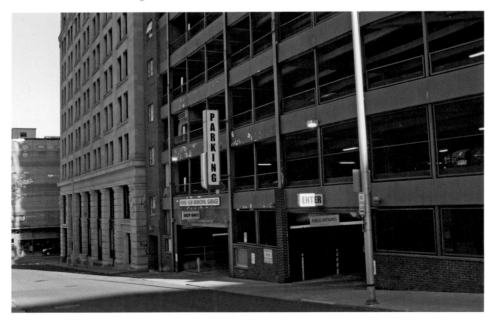

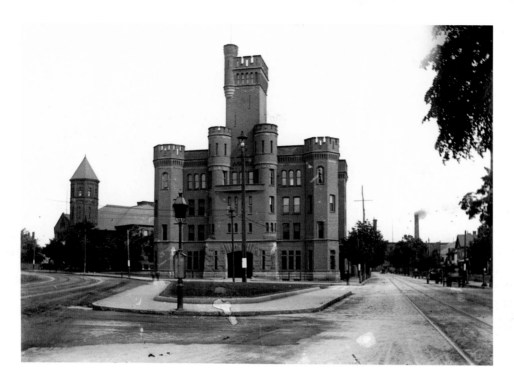

ARMORY: This 1895 view shows the Armory with its large central tower. The Armory was built in 1889-90 at cost of $131,971 and is presently used as a Massachusetts Military Museum. To the left above is the Salisbury Street School that in 1911 became North High School and is now condominiums. On the right above were houses and a small diner on the corner. Worcester Voke used much of this land for training shops. Today the area to the right is used for commercial, educational and retail purposes.

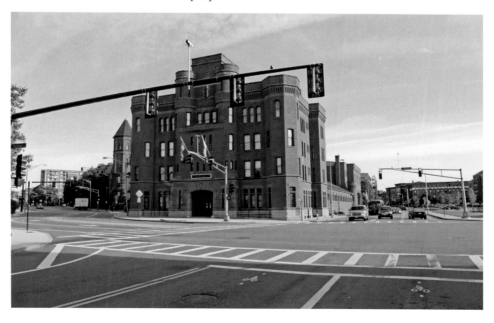

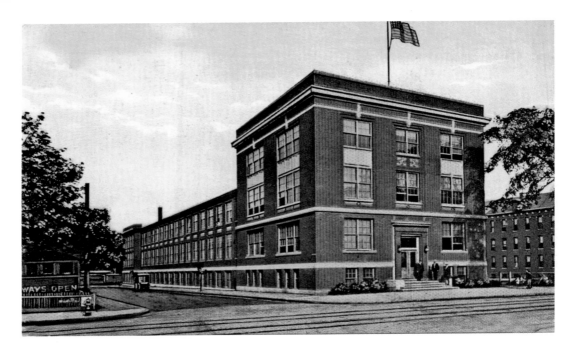

WORCESTER TRADE SCHOOL: This unique view of Worcester Trade School (boys only) was taken shortly after it opened in 1910. It is rather interesting that, as can be seen in the view below, it appears that an addition was built first and then the Main School was added on. It is presently vacant as a new high school, Worcester Tech High School, was opened on August 28, 2006 on Skyline Drive.

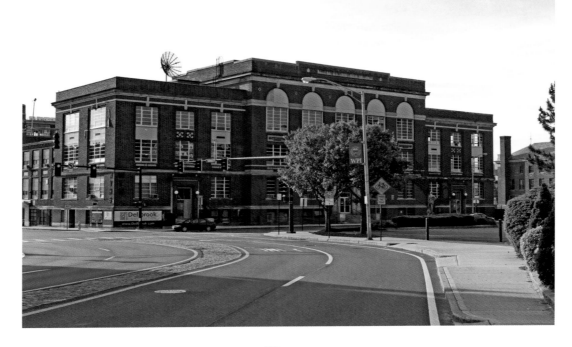

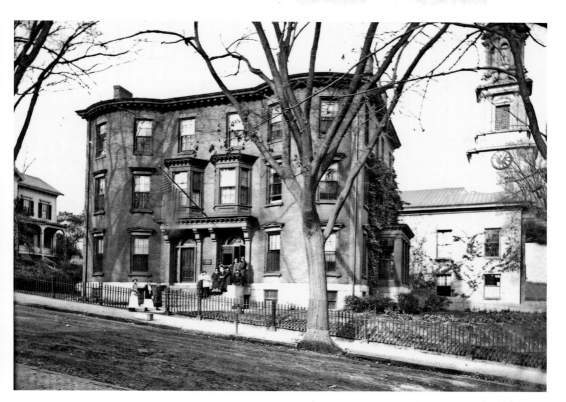

GIRLS TRADE SCHOOL: When Worcester Trade High School opened in 1910 it was only for boys. Seventy-five girls received their own Trade School with the September 20, 1911 opening of the school on State Street next to the Unitarian Church. The school was formerly the home of Rejoice Newton a famous Worcester attorney. The above view has several students outside the main entrance in 1913. Today that site is a parking lot and the Wesley Methodist Church has been built across the street.

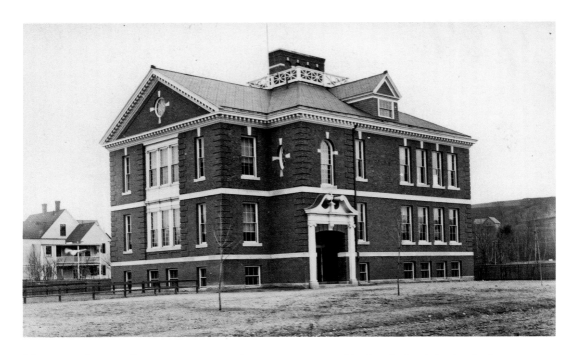

MIDLAND STREET SCHOOL: Worcester built numerous neighborhood schools in the closing two decades of the nineteenth century. One of the more elegant designs (Architect Lucius W. Briggs) was Midland Street School, at the corner of Midland and Huntley Streets. The school is shown in this late 1890s picture shortly after its 1897 opening. Rapid growth in the Newton Square area necessitated an expansion in 1915. Unlike some additions to old schools this one was architecturally similar and mirrored the original structure.

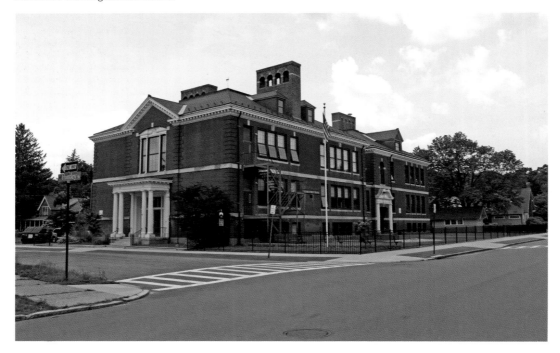

BANCROFT SCHOOL: By the end of the nineteenth century Worcester was home to many private educational institutions at all levels. Bancroft School, at 111 Elm Street opened in 1900, the year of the above photo. It was named after the historian and founder of Annapolis, George Bancroft. In need of much more space the school moved to Sever Street in 1923. In 1958 the school made its final move to Shore Drive and the Sever Street location became home to Becker Junior College. Today the Elm Street site is used for a professional office building.

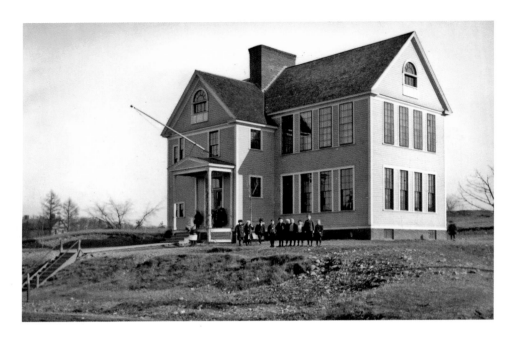

TROWBRIDGEVILLE SCHOOL: This late 1890s photo is of Trowbridgeville School, which opened in 1897 to serve fifty-nine students, was at the corner of Webster and Bernice Streets. It was expanded in 1913 and closed in 1932 when Heard Street School opened. Like a number of Worcester schools of the period it was designed by Elbridge Boyden. Katherine L. Broderick, was the first Principal and was paid $500 for the year. The school was purchased by the Swedish Cemetery Corporation and torn down in 1948.

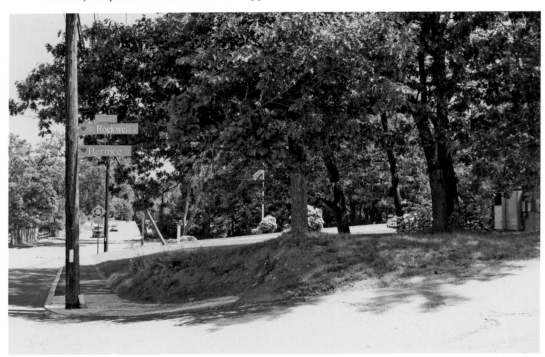

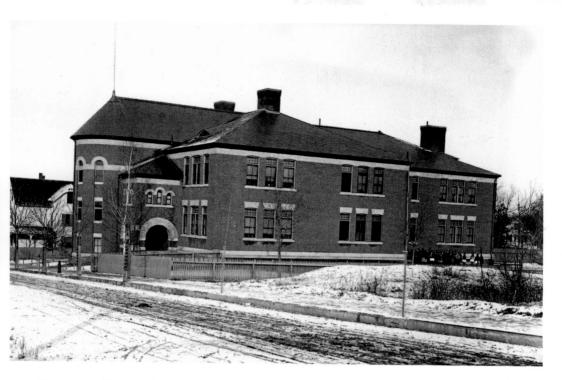

DOWNING STREET SCHOOL: The Downing Street School sits nearly alone at 92 Downing Street in this early 1890s view. The school was designed by W. R. Forbush and built by W. F. Dearborn & Son. Within ten years of opening it was serving over 500 students. It closed in 1993 and Clark University bought it and began a large renovation in 2001. Today it is called the Traina Center for the Arts named after the highly respected and beloved Richard P. Traina who served as Clark University's President for sixteen years from 1984-2000.

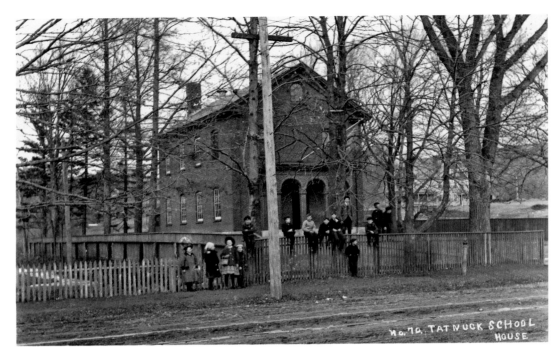

TATNUCK SCHOOL: Tatnuck School was first occupied in 1859 and was closed in 1910. Designed by Boyden, Ball & Samuel D. Harding, it was located on Pleasant Street at the corner of Chestnut (now Copperfield). In the picture above from *c.* 1900 it appears the children are eagerly posing for the photographer, as photography was still a novelty to many at this time. In 1924 the school was removed to make room for the Tatnuck Fire Station.

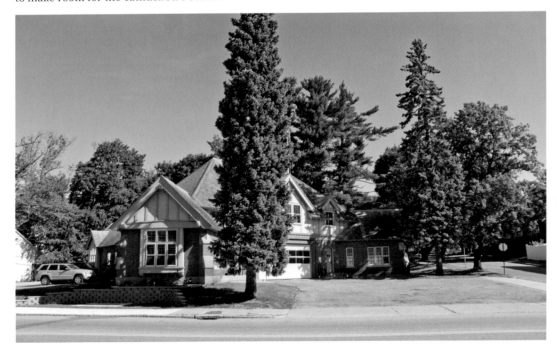

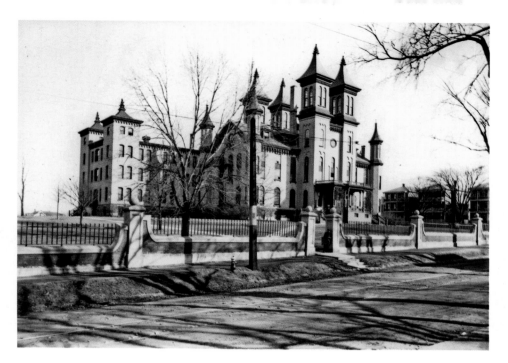

DAVIS HALL: Davis Hall at Worcester Academy in *c.* 1900 was a magnificent structure gracing Providence Street with its many towers. It was designed by Elbridge Boyden and built in 1852. It was a building of many functions such as a Medical College, Ladies' Collegiate Institute, and the Dale Hospital for wounded Civil War soldiers. Worcester Academy acquired it in 1870 and used it until 1964 when it was torn down and replaced by two separate brick buildings. Below a photograph from the same location shows the dramatic transition.

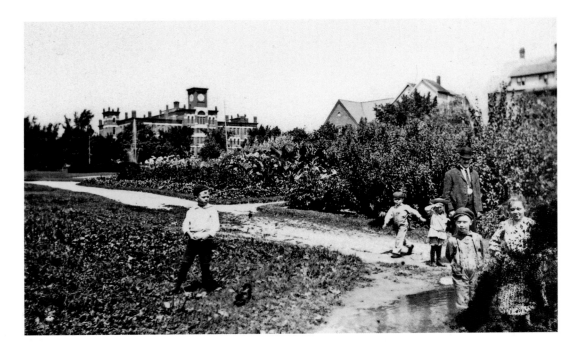

UNIVERSITY PARK: This early 1890s view of children playing next to the water in University Park shows Clark University in background. The view below taken 120 years later shows a park under renovation and the original Clark building nearly concealed by some of the new buildings of an expansive Clark University. Clark University opened in 1889 as a graduate school where both President Theodore Roosevelt and Dr. Sigmund Freud spoke. Dr. Robert Goddard, the father of rocket science, was a professor there.

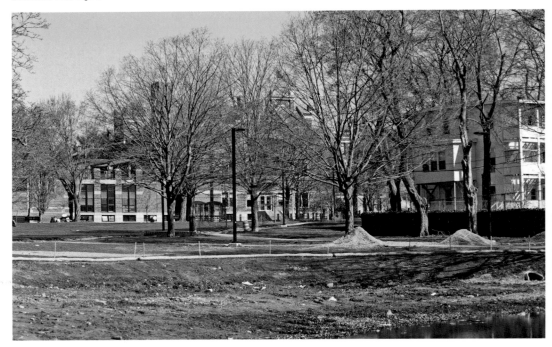

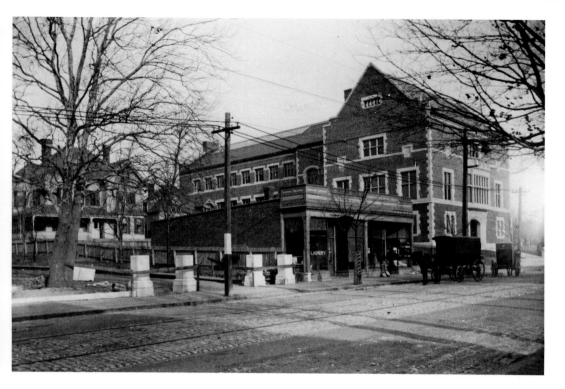

CLARK UNIVERSITY: In this *c.* 1902 photograph of Clark University on Main Street is shown Clark's third building. It was built as the library with more than $100,000 provided by Clark's founder Jonas Clark. It was designed by Frost, Briggs & Chamberlain and built in College Gothic style. The photograph above contains the University Laundry and a small grocery store close to Main Street that is now the location of a large academic building.

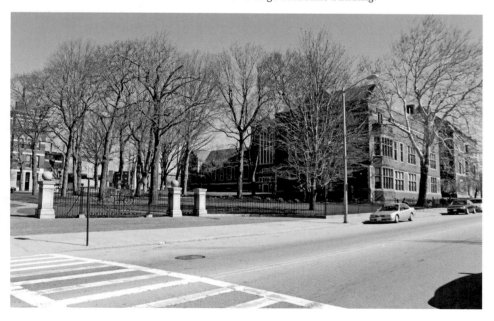

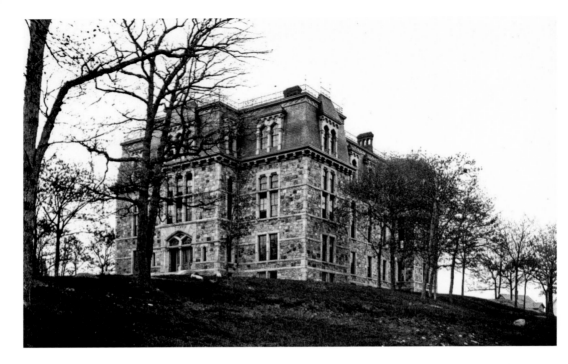

WORCESTER STATE NORMAL SCHOOL: The Worcester State Normal School was authorized by Legislative Act in 1871 and opened in 1874. The Act stated, rather vaguely, 'Every opportunity is seized to give pupils the benefit of whatever tends to fit them for the work of teaching'. It was located on five acres of land known as St. Anne's Hill at the corner of Eastern Avenue and Normal Street. Closed in 1932 the college moved to Chandler Street where today it is Worcester State University. The above building was torn down in 1943 and City View School was built on the site in 1991.

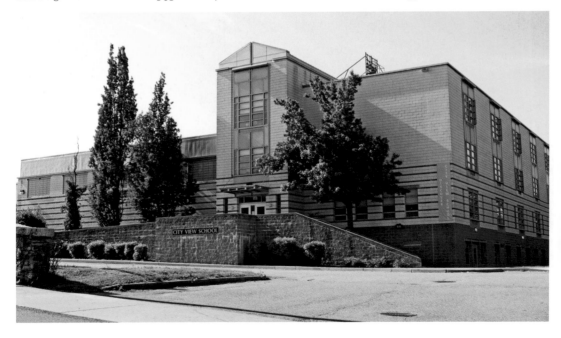

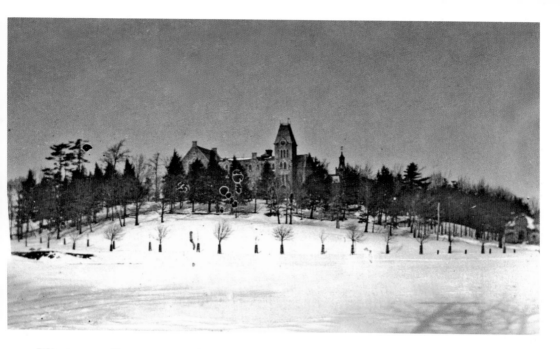

WORCESTER POLYTECHNIC INSTITUTE: Worcester Polytechnic Institute's Boynton Hall sits at the end of a long field in this rare *c.* 1890 snowy winter view. Boynton Hall was built in 1868 and named after John Boynton of Templeton who founded the Worcester Free Institute of Industrial Sciences in 1865, now known as WPI. The streets, cars and buildings in the view below are evidence of a vastly changed landscape.

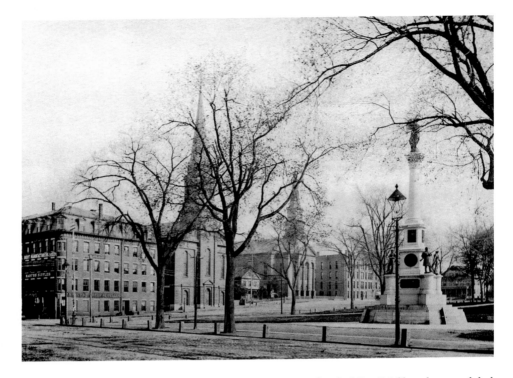

SALEM SQUARE: This 1884 view of Salem Square shows the 1836 Baptist Church, remodeled in 1871, on the left and the Notre Dame des Canadien Church on the right. The C. C. Houghton Boot manufacturers used the five-story brick building on the corner of Front and Salem Streets. Horse-drawn trolleys would have used the trolley tracks in the foreground on Front Street, as electric trolleys were still nearly ten years away. The Civil War Statue is all that remains today.

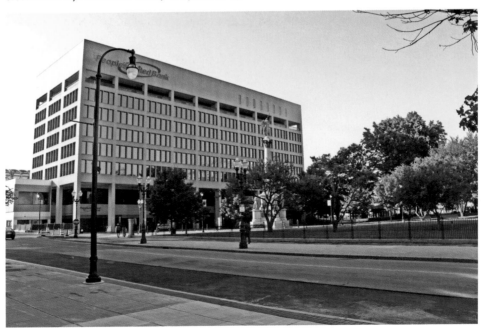

METHODIST CHURCH: The view above has undergone a tremendous change. The Park Avenue Methodist Church located at 418-20 Park Avenue was founded in 1891. The structure was destroyed by fire and its successor, the Aldersgate United Methodist Church was built in 1962. Today the site, next to a pharmacy on the right, is a fast food business.

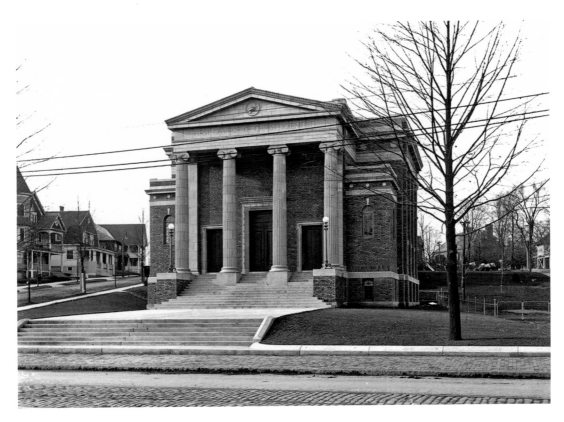

CHURCH OF CHRIST SCIENTIST: This 1913 photograph was taken the year that the First Church of Christ Scientist opened. Located at 880 Main Street it is still a viable building being used as a cultural center.

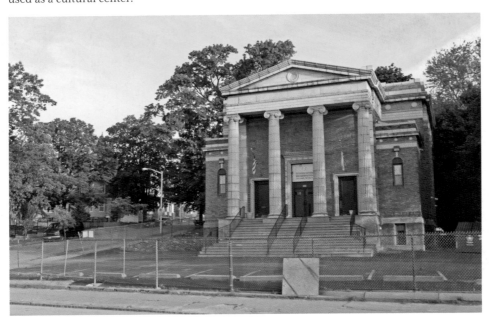

WALNUT STREET:
Looking down Walnut Street toward Main Street in this late 1890s view we can see the tower of the Grace Methodist Episcopal Church, which was founded in 1867. It was located near the corner of Walnut Street and Maple Terrace. Next door, directly at the corner is the Pelham Hotel at 5 Walnut Street. Mechanics Hall on Main Street can be seen in the distant center in both photographs.

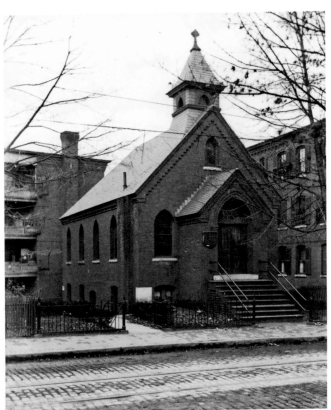

CHANDLER STREET
CHURCH: This small church at 100 Chandler Street was the home to the congregation of the First German Evangelical Lutheran Church. Founded in 1888 it is shown in the top photo in 1905. Today the church is still in use and is called the Iglesia Del Dios Viviente. One could easily drive by without seeing it because it is tucked in behind trees.

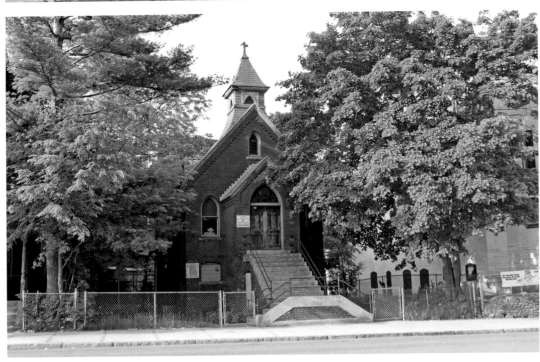

CENTRAL CHURCH: This 1884 photograph depicts the old Central Church on Main Street just north of George Street. This church was erected in 1826 by Daniel Waldo and was used until a new church was built on Salisbury Street in 1884-5. The Elwood Adams building sits to the right in both views. Elwood Adams is the oldest continuous operating hardware store in the U.S. The photograph below shows a parking lot where the church once stood.

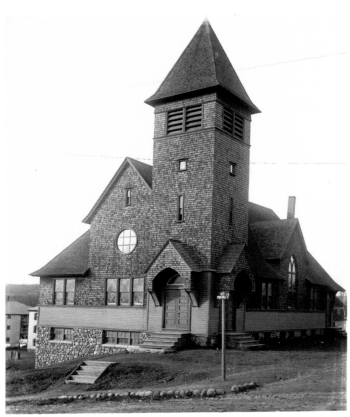

GREENDALE
COMMUNITY: The
Greendale community was
very active and tight knit
with its own Improvement
Society. The Greendale
People's Church founded in
1895 on the corner of Francis
Street and Bradley Avenue
(now Leeds Street) was a
hub of community activity.
Today the church is greatly
modified and expanded
from the *c.* 1900 view above
and is still a very active part
of the Worcester community.

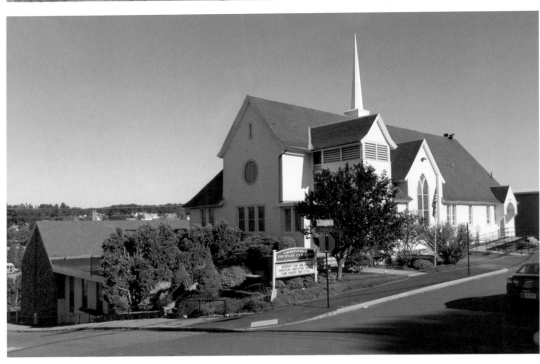

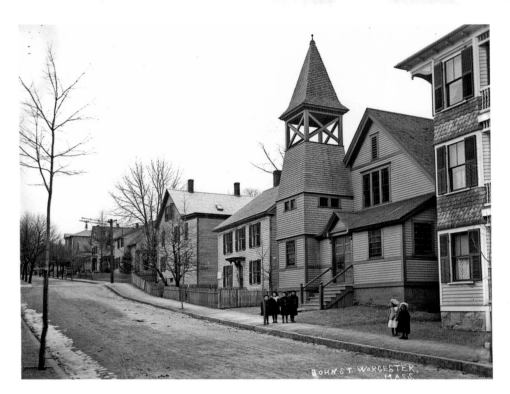

JOHN STREET BAPTIST CHURCH: This street view of the John Street Baptist Church, founded in 1883, was taken in *c.* 1900 and shows a quiet residential neighborhood with six children posing for the camera. This church was known as the Mt. Olive Baptist Church in the 1888 Worcester Directory. Today the church has been slightly remodeled and the homes on both sides still stand.

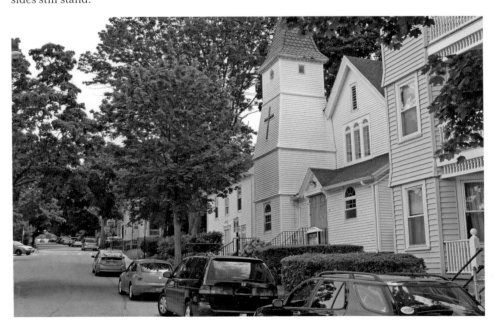

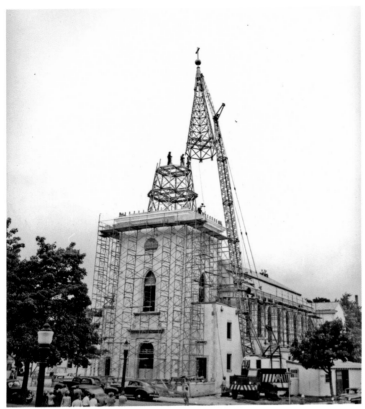

TRINITY EVANGELICAL LUTHERAN CHURCH: A crane is used to lift the tower framework for the Trinity Evangelical Lutheran Church into place. This church at 73 Lancaster Street on the corner Salisbury Street was built was built in 1952 and united three other Lutheran churches in Worcester. Below as it looks today with its addition to the left.

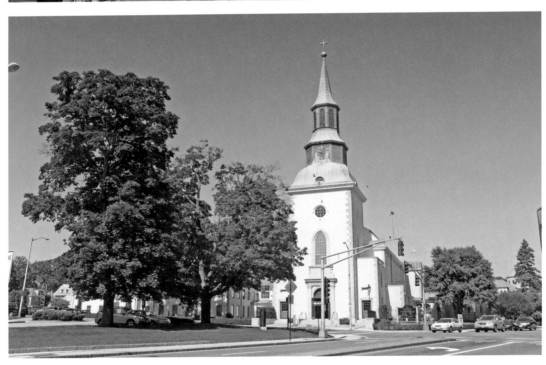

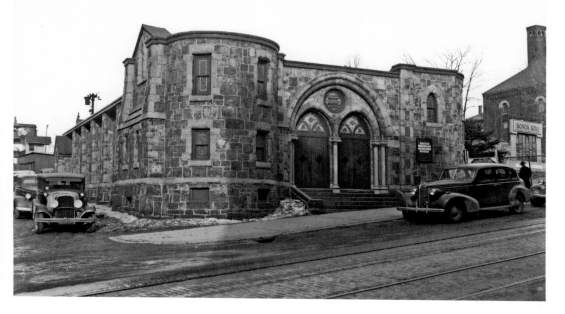

GHANA METHODIST CHURCH: The Swedish-Finnish Lutheran congregation moved to this new building in 1906. Located at the corner of Carbon and Belmont Streets, this *c.* 1940 photograph shows the stone lower vestibule of the church. The church changed its name to Evangelical Bethany Church in 1928 and twenty years later merged with two other Lutheran churches to form the Trinity Lutheran at 73 Lancaster. It is now called the Ghana Methodist Church.

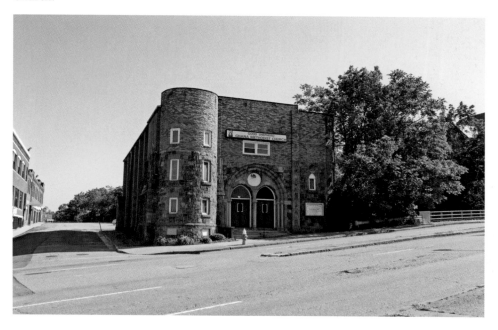

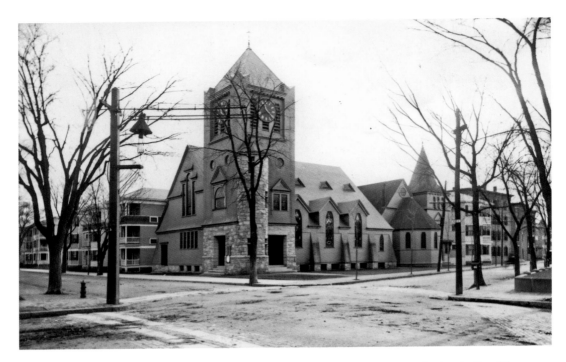

PARK CONGREGATIONAL CHURCH: One of the tasks of the City Missionary Society in the 1880s was to help organize new churches in Worcester. One of those churches is shown in this *c.* 1900 view of the Park Congregational Church at the corner of Russell and Elm Streets. Park Congregational was built in 1886-87 and still stands today across the street from Saint Spyridon Church. Both churches are opposite Elm Park.

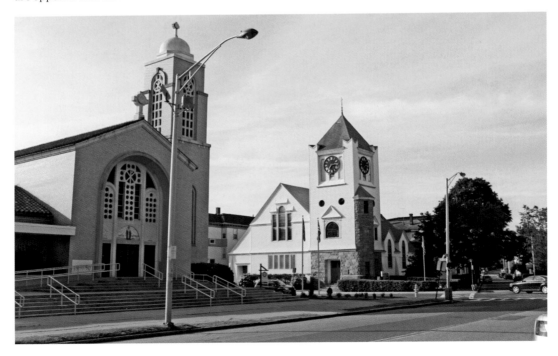

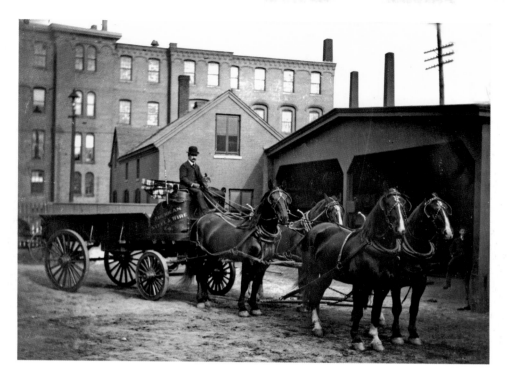

WASHBURN & MOEN: This *c.* 1900 photograph depicts a rather well dressed driver sitting at the reins of what appears to be an empty American Steel & Wire delivery wagon. The fact that the wagon is hitched to four horses is an indication of an ability to pull a heavy load of wire. The slightly wider-angle shot below catches the Washburn & Moen name on the building located on Grove Street. American Steel & Wire was a successor to Washburn & Moen.

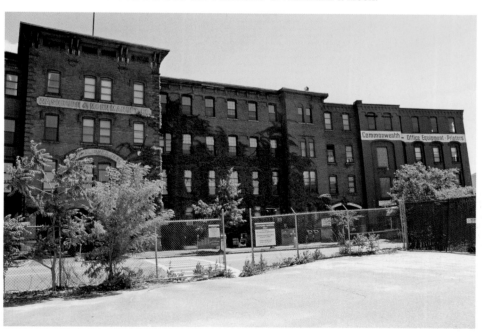

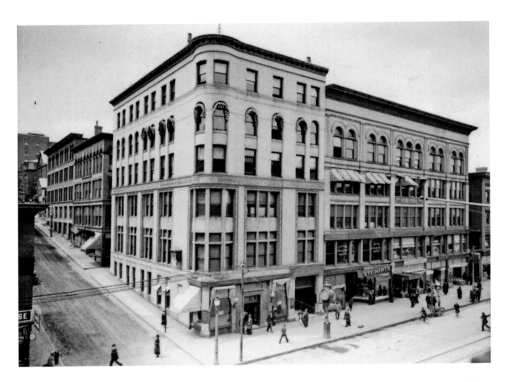

WORCESTER FIVE CENTS SAVINGS BANK: In 1900 it was a busy scene in front of the Worcester Five Cents Savings Bank Building at 316 Main Street which was designed by Stephen Earle and built in 1891. The Day Building on the right was designed by Barker and Nourse and built in 1897-98. Above, Steinert's piano store, a Worcester business for many decades, can be seen on the first floor of the Day Building.

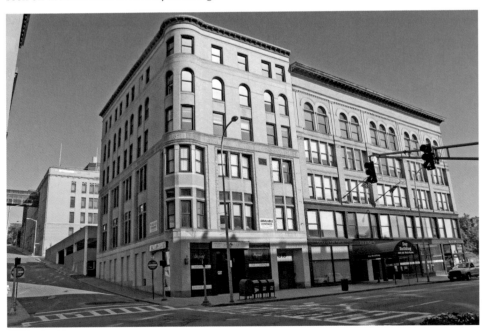

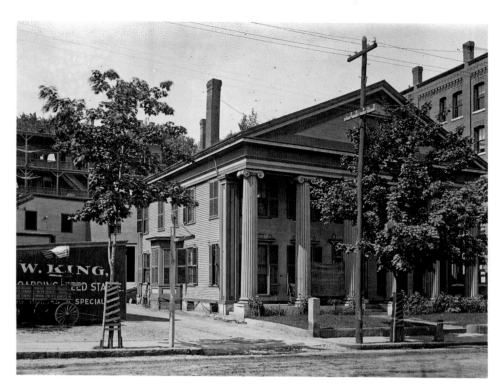

PIEDMONT STREET: Charles W. King had his home and business at 13 Piedmont Street as shown in this *c.* 1904 photograph. Mr. King ran his wagon repair and livery business from 1885 until 1908 and his ambulance service during 1897 and 1898. The building later became home to Manoog Plumbing. In the same location today is the Iglesia Evangelica de Worcester and in the background a large apartment house can be seen both views.

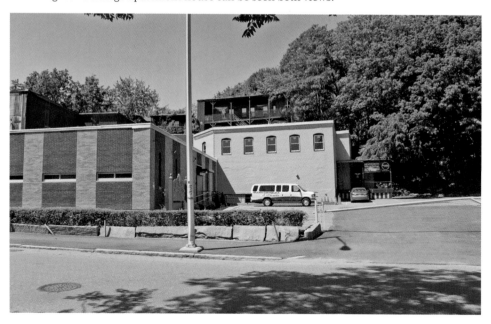

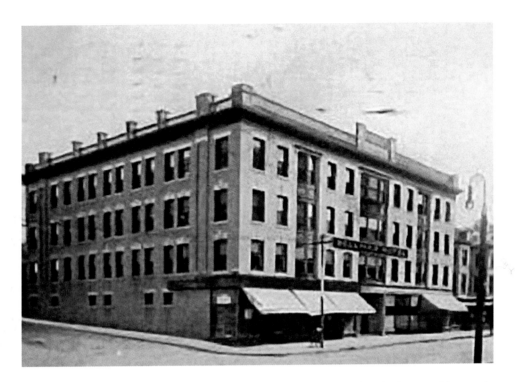

BELLMAR: Worcester had a number of private boarding house hotels that would cater to travelers wishing to stay more than a few days. One of those was the Bellmar at 667 Main Street at the corner of Ionic Avenue across from the Aurora Hotel. The photo below shows that the right side has been altered most likely due to a fire and the bottom floor contains all retail establishments.

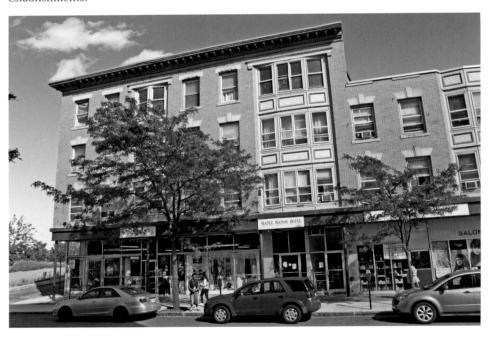

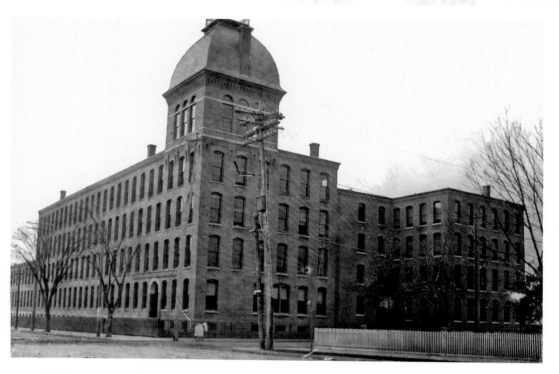

HARRINGTON & RICHARDSON ARMS BUILDING: The Harrington & Richardson Arms Building dominated this location at the corner of Chandler Street and Park Avenue from 1893 to 1985 when it was torn down. The company began in 1871 at 18 Manchester Street and in 1876 moved to 31 Hermon Street, where it remained for sixteen years till it moved to the 120,000 square foot building seen above. Once an employer of 2,000 the company shut down this plant in 1974 and moved to Gardner. The site was vacant for many years until a pharmacy was built.

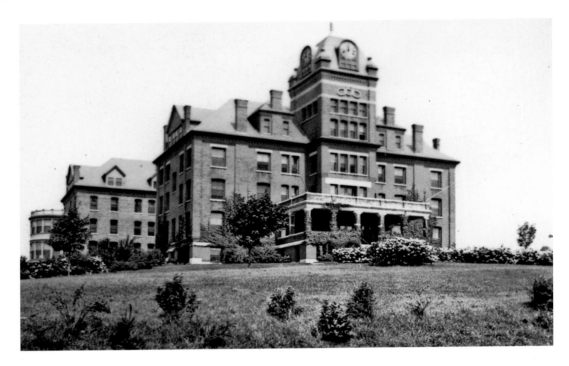

ODD FELLOWS HOME: This *c.* 1904 photograph shows the splendor of the Odd Fellows Home on Randolph Road. It was begun in 1890 and completed in 1892. The building was designed by Barker & Nourse and has a five-story central clock tower. Today the building is vacant and slated for demolition in order to construct a two building rest home with eighty-two beds.

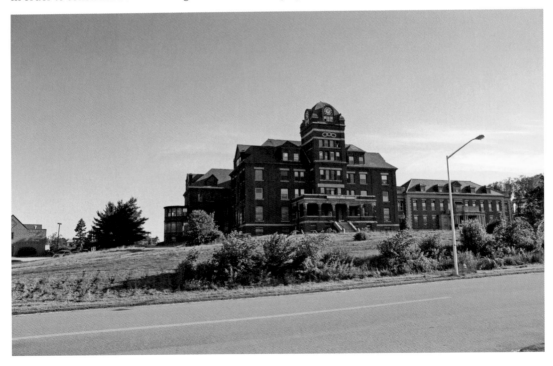

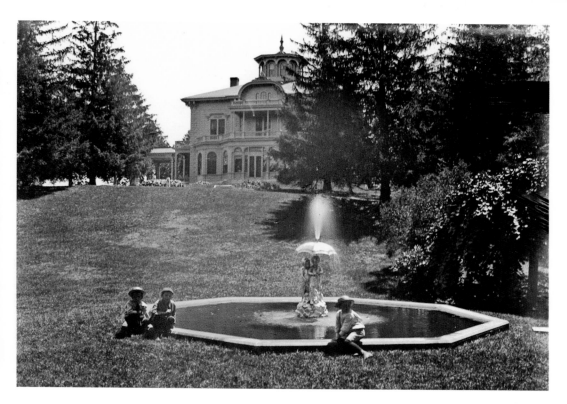

LORING COES: Three children pose in front of the fountain in front of the Loring Coes twenty-five room mansion at 1049 Main Street. Coes was a noted Worcester Industrialist and the inventor of the monkey wrench. The home was built in 1872 to overlook Webster Square. Sadly the home was demolished in 1933 and later closer to Main Street the site became the Worcester Ice Arena. Today the arena is broken into several retail businesses.

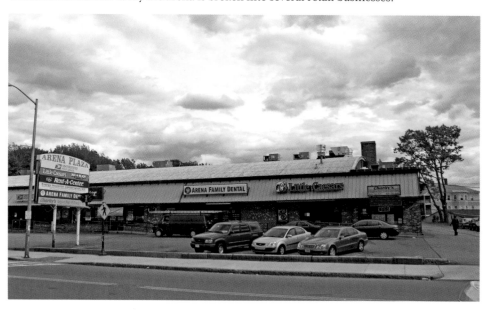

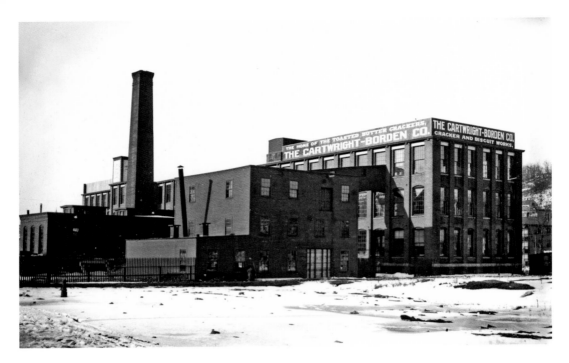

CARTWRIGHT-BORDEN COMPANY: The Cartwright-Borden Company shown in this *c.* 1902 view began manufacturing biscuits and crackers in 1901. Located at the corner of Nebraska and Winona Streets off Shrewsbury Street, it is much harder to pinpoint the location today because Winona Street no longer exists. An 1899 map shows that it was directly across from Marshall Street which today would run approximately through the middle of the restaurant in the photo below. Envelope Terrace where the photo was taken from did not exist in 1899.

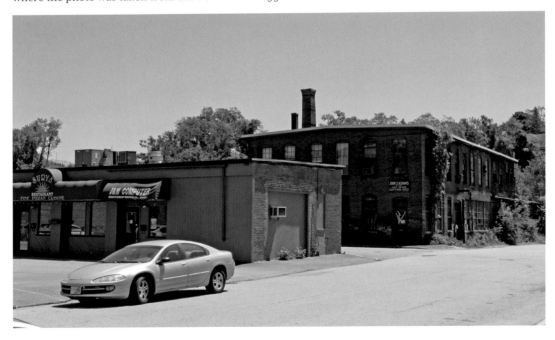

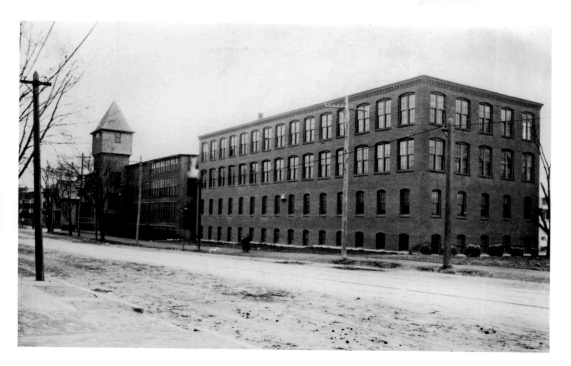

WORCESTER SLIPPER COMPANY: The Worcester Slipper Company seen above in this 1901 picture, was established in 1899 by J. Prescott Grosvner. Located at 370 Park Avenue, the company was a large manufacturer of carriage and automobile boots, slippers and Grosvner's Firfelt Footwear. Coppus Engineering operated here in later years and in the early 1980s it was torn down. The site is now a parking lot for the liquor store behind it.

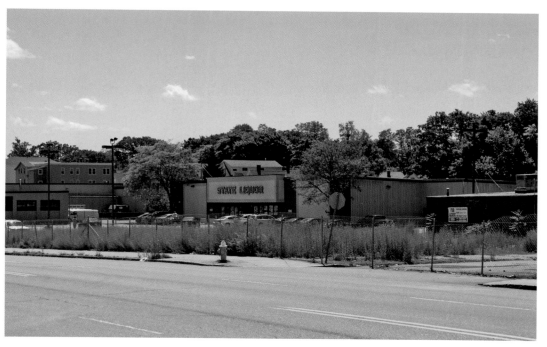

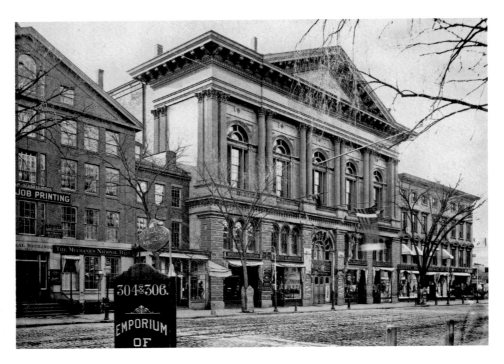

MECHANICS HALL: This 1884 photograph shows the magnificent Mechanics Hall. It was designed by Elbridge Boyden at a cost to the Worcester Mechanics Association of approximately $162,000. Dedicated on March 19, 1857, its 130-foot hall has long been known as one of the great acoustic venues in the country. It has hosted speakers like Mark Twain, Charles Dickens and President Bill Clinton. It fell into disrepair and was used for roller skating and boxing but was saved and restored in 1977. The 1896 Central Exchange building to the left replaced the old Exchange Building of 1844.

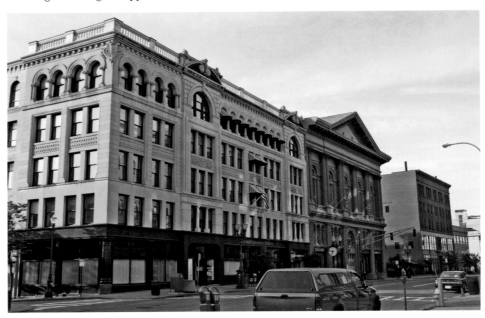

KRESGE'S: In this 1890s photo this seven-story building stood as an anchor at the corner of Main and Chatham Streets. In the early 1900s Kresge's occupied the corner store across from the Great Atlantic and Pacific Tea Company. Kresge's was founded by Sebastian Spering Kresge (1867-1966) in 1899 and would later become Kmart in 1977. The A&P, an American icon, began in 1859 as a tea company. Today the area is a parking lot with the modernized Denholms' façade next door.

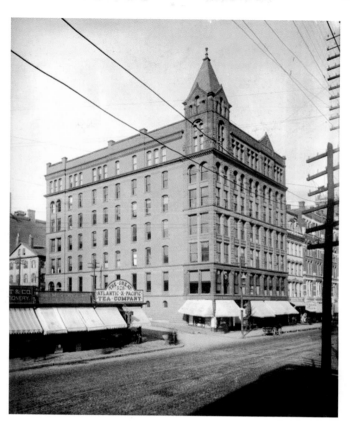

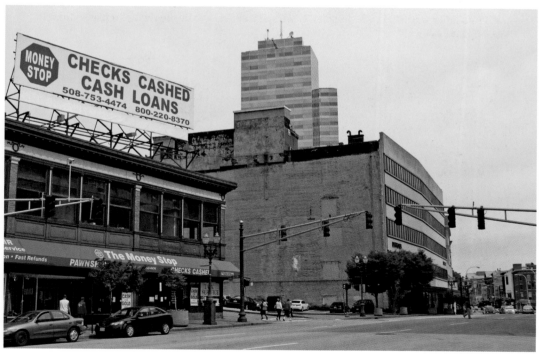

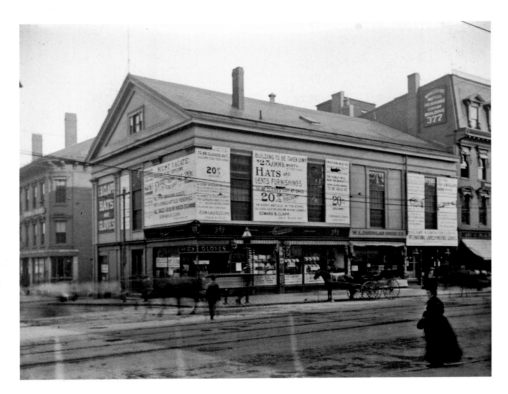

365 MAIN STREET: This early structure at 365 Main Street was home to a hat and clothing retailer named Edward B. Clapp. The sign in the center of the photograph says, 'Building to be taken down . . . $25,000 in first class hats and gents furnishings to be closed out at once . . . 20% discount'. The sign helps to date the photo because the building in the photo below was built in 1906. Today it is used by the Bank of Boston.

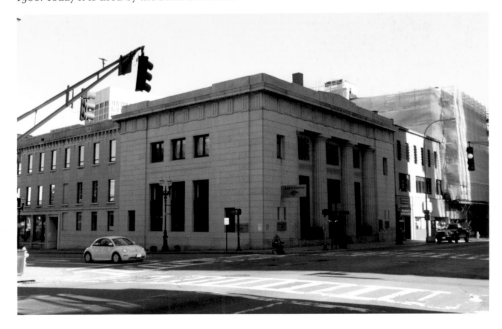

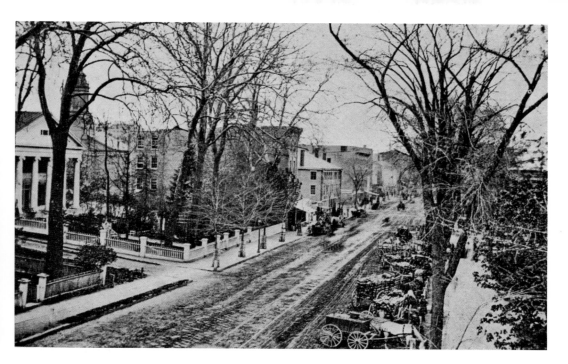

MAIN STREET VIEWS: This series of four Main Street views begins with the above 1864 view from the corner of Park (Franklin) and Main Streets looking north toward Pleasant Street. Note the large number of wagons parked in front of what would today be City Hall. The raised left side of the street was leveled in the 1870s. The photo below was taken in c. 1900 and shows a vastly different street with large commercial buildings replacing homes.

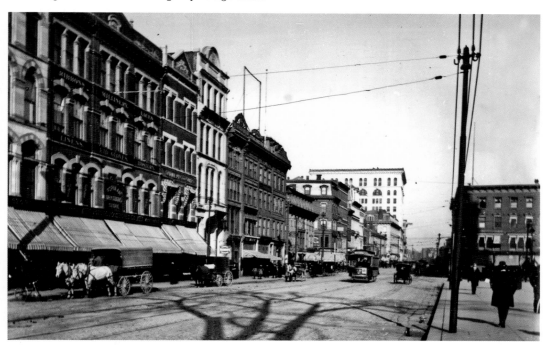

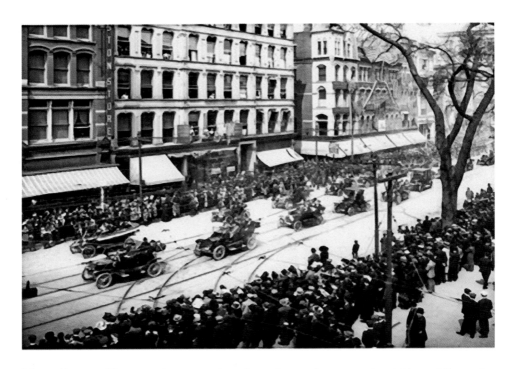

MAIN STREET VIEWS: The *c.* 1917 view above shows a large crowd watching a fall parade. The recent photo below shows several large commercial buildings have been demolished in favor of green space next to the glass Sovereign Bank Tower that is located at the corner of Pleasant and Main Streets.

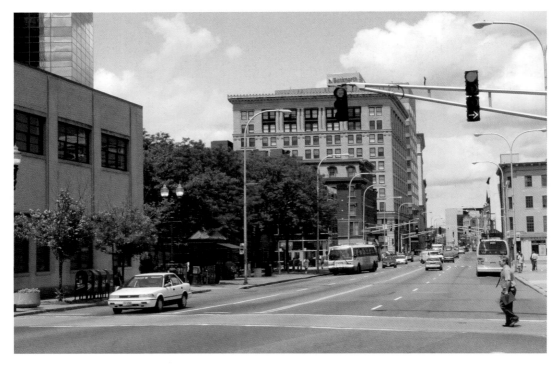

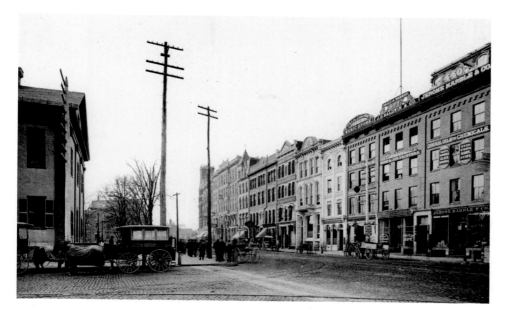

OLD MAIN STREET: On the left is old City Hall and parked next to it is an enclosed wagon with a lower back door that may indicate usage as a hearse. This nostalgic 1884 view gives the observer a glimpse of the trolley track lined cobblestone streets of the period. 1907 graduates from the College of the Holy Cross are marching down Main Street in this close up photo of the same location. The last building on the right in both pictures is Denholm & McKay (Boston Store).

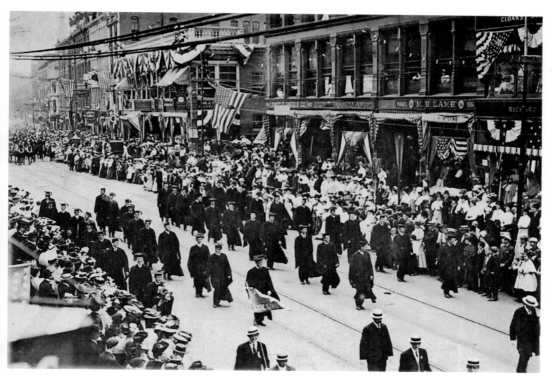

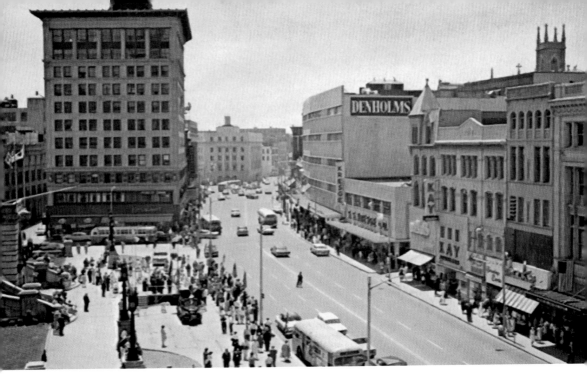

1960 MAIN STREET: By the 1960s Denholm & McKay had a new façade and Kresge's, soon to become Kmart, occupied the yellow brick building next door. Below is Main Street with nineteenth century buildings razed and replaced with green space.

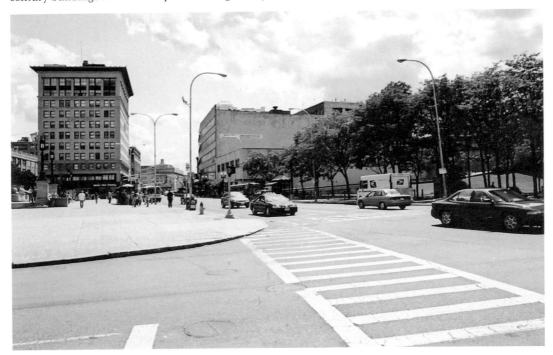

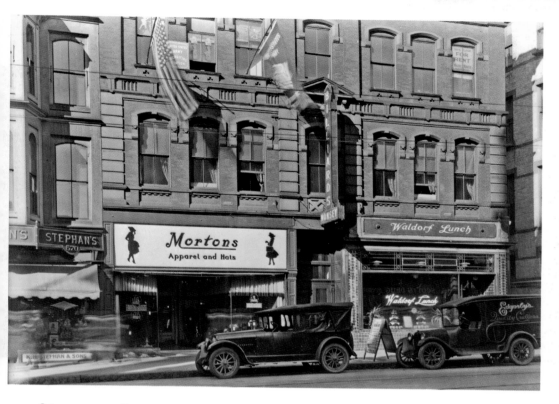

COMMERCIAL BLOCK: This commercial block at 568-570 Main Street was home to several retail businesses. Stephan's was at 570 and Morton's at 568. Monsey's billiards moved here from 33 Pearl Street where they also operated a bowling alley. Today the site is the Federal Plaza Municipal Garage.

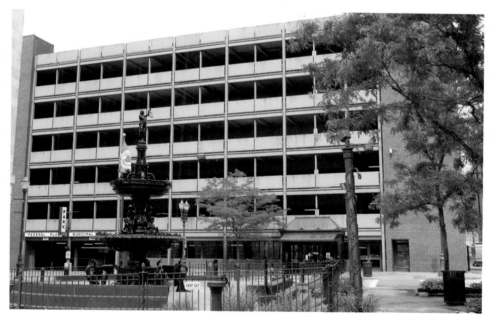

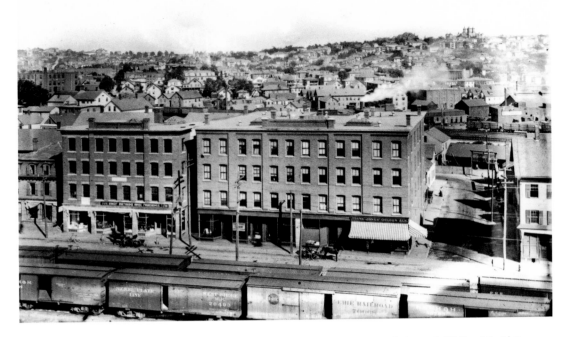

NORTHRIDGE FURNITURE The Northridge Furniture store was a fixture at 166 Southbridge Street for many decades. It was located in the smaller four-story building in the above *c.* 1898 view. The building was destroyed by fire; the larger building demolished. Above, on the right in the distance can be seen the towers of Worcester Academy's Davis Hall. The photograph below, taken from the upper floor of the Masonic Temple, shows Coney Island, a Worcester 'institution' since 1918, with a used car lot next door where Northridge Furniture once stood.

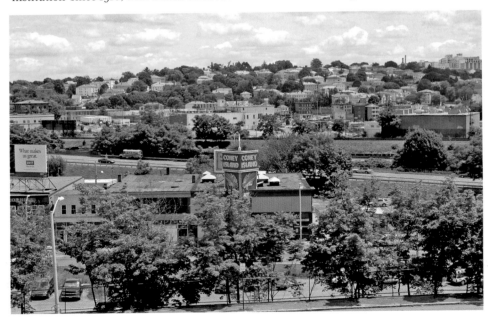

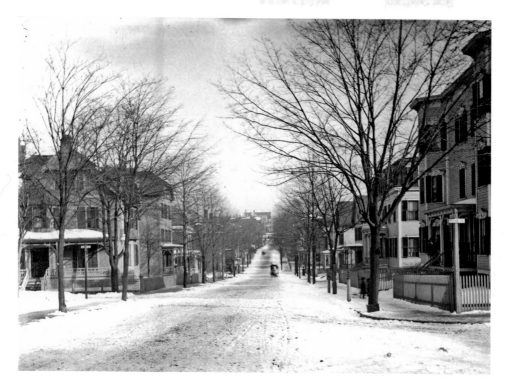

AUSTIN STREET: This *c.* 1906 photo shows a serene winter day on Austin Street at the corner of Queen Street. Austin Street runs from Main Street, across from the Registry of Motor Vehicles, to Dewey Street near Chandler. Snowy winter views like this are much more uncommon for this time period. The scene below is unusual in that it only reveals cosmetic changes to the neighborhood over the past century.

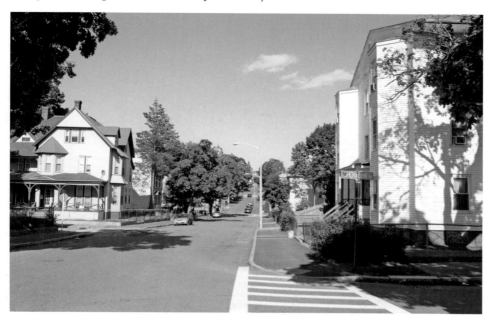

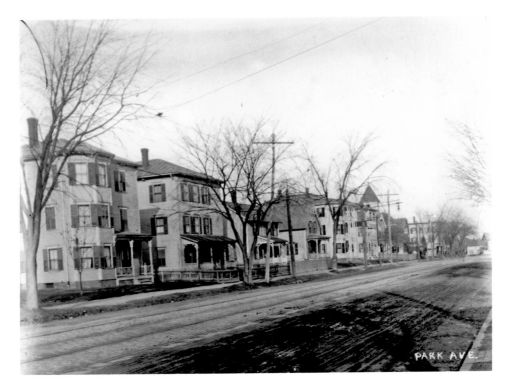

PARK AVENUE: The tower of the Park Avenue Methodist Church can be seen in the distance of this *c.* 1900 view of Park Avenue looking toward May Street. The church, founded in 1891, was nestled among a line of three deckers. Three deckers were a familiar and rapidly increasing sight in Worcester as it approached the twentieth century. The view of this area today is in stark contrast to photo above. The tall gable end of the Park Avenue Fire Station is barely visible to the right of the center tree in the view below.

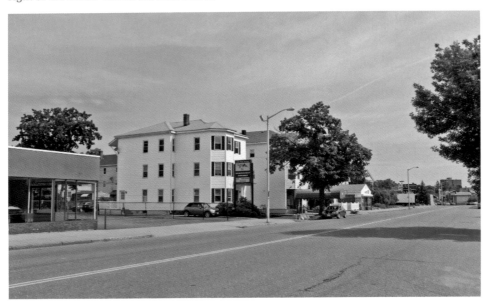

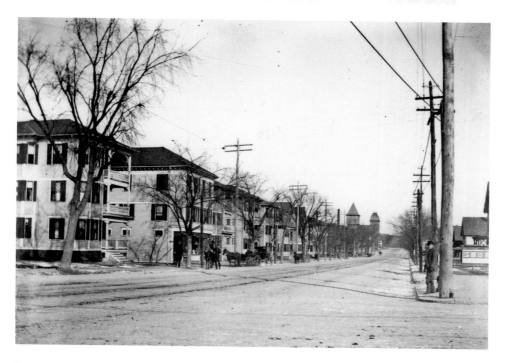

PARK AVENUE NORTH: This view of Park Avenue taken in *c.* 1898 has the observer looking north from the intersection of May Street. The two towers in the distance are of the Worcester Slipper Company at 370 Park Avenue and the Harrington Richardson Arms Company next to Chandler Street. Notice a small diner on the right in an area now occupied by a Chinese restaurant. The picture below shows the complete change that has taken place in this area over the last 115 years.

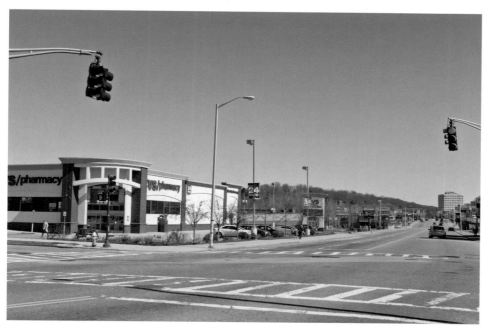

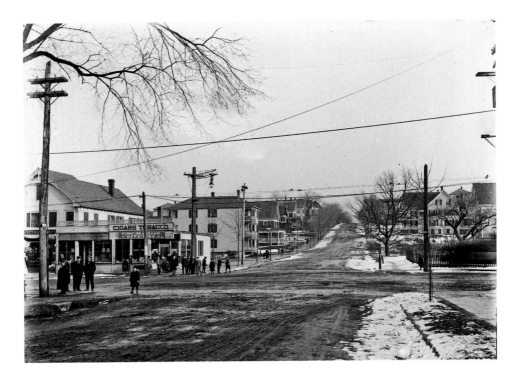

MAY STREET CORNER: In this *c.* 1900 scene a curious group of adults and children pose for the photographer at the corner of May Street and Park Avenue. The Manhattan Grocery Market, newly opened, had an interesting combination of businesses: cigars, tobacco and furniture & organ repair. The same location today shows a 7 Eleven with a pharmacy and a pub across the street.

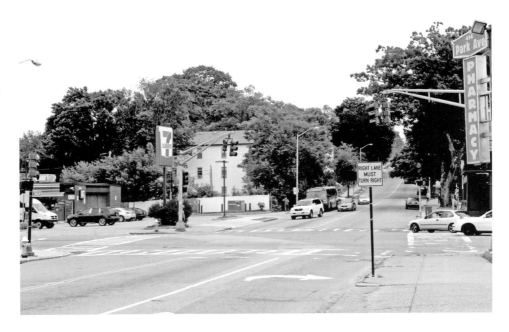

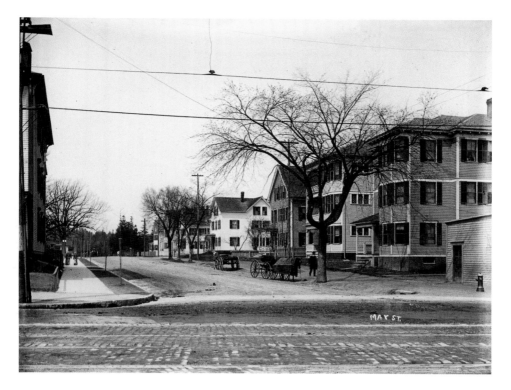

MAY STREET FROM PARK AVENUE: In the 1890s May Street, viewed from Park Avenue, was a typical serene, three-decker-lined byway. With no leaves on the trees and the horse in the foreground covered with a blanket, one could assume it was a cold fall or spring day. The view shows much change. Nearly all the homes have been taken down and replaced by retail business. Note the cobblestones and trolley tracks on Park Avenue.

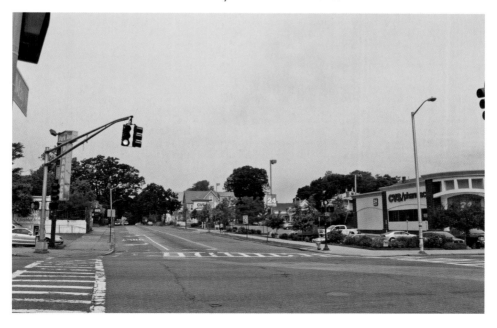

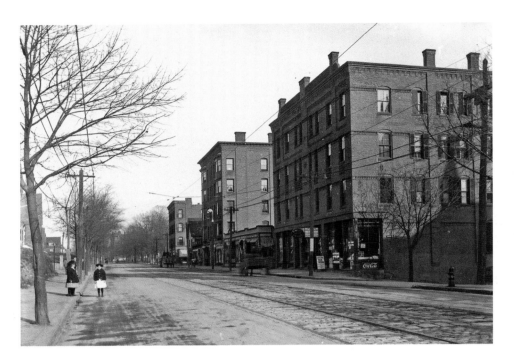

MAIN STREET: The only street traffic in this 1902 photograph of Main Street is two young girls and two wagons. Gardner Street is to the right by the by the fire hydrant. Close examination of the photo above shows H. Stone Boot & Shoe Repair shop and H. Wolfe Custom Tailors as businesses in the first building. Today cars line the streets and the apartment houses have been razed. Below, the Pilgrim Congregational Church, founded in 1885 at 919 Main Street, existed at the time of the photo above.

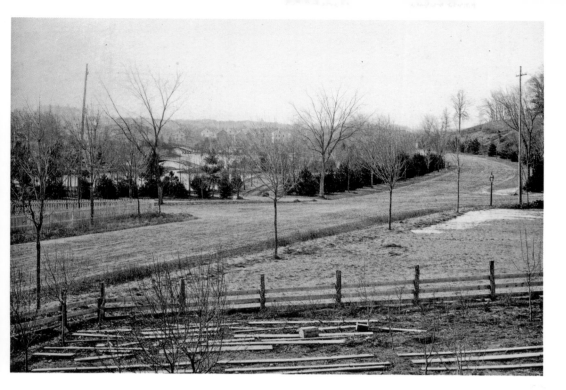

ELM PARK: Much further north along Park Avenue we come to this scene at the corner of Highland Street and Park Avenue with Elm Park at one corner. What is now an exceptionally busy intersection was a quiet country setting in 1884. Elm Park remains much the same today with a supermarket across Highland Street and in the distance is the eleven-story 255 Park Avenue office building.

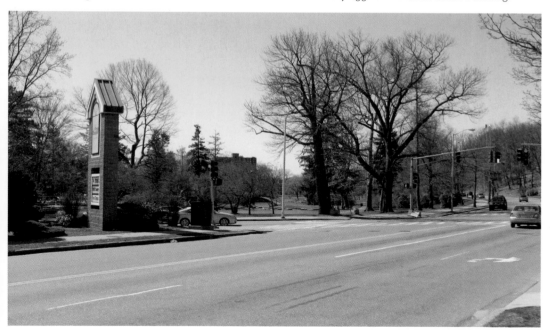

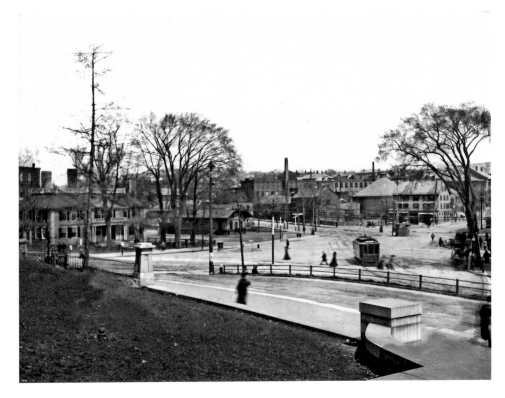

LINCOLN SQUARE: The above view of Lincoln Square was taken from the steps of the courthouse in *c.* 1900 and as can be seen below, has few similarities today. Missing is the Salisbury Mansion on the left as it was moved to 40 Highland Street in 1929. The Lincoln Square Boston and Maine train station and nearly all other structures have been demolished.

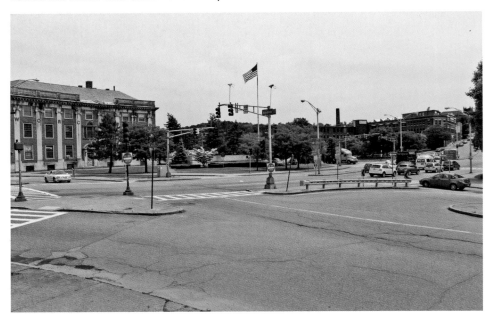

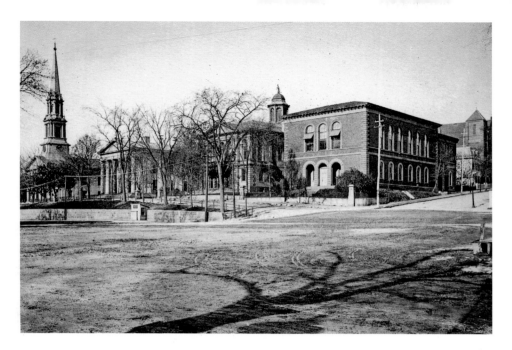

COURT HILL: In 1884 Court Hill, from left to right, was the site of the Unitarian Church, the new and old Court houses, the Antiquarian Society and the Lincoln Square Baptist Church. The Unitarian Church was built in 1851, badly damaged by fires and the 1938 hurricane and restored. The original courthouse of 1845 underwent a massive renovation and expansion in 1898-99 to look like what is seen below. Today there is a large new courthouse at 225 Main Street. The Antiquarian Society moved to Salisbury Street as both it and the Baptist Church were lost to courthouse expansion.

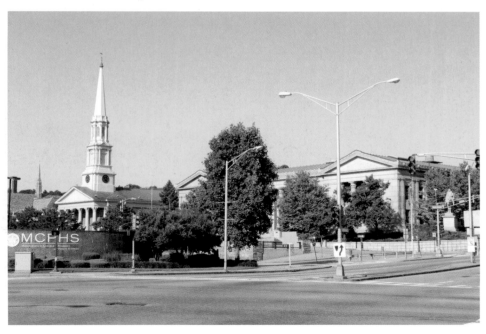

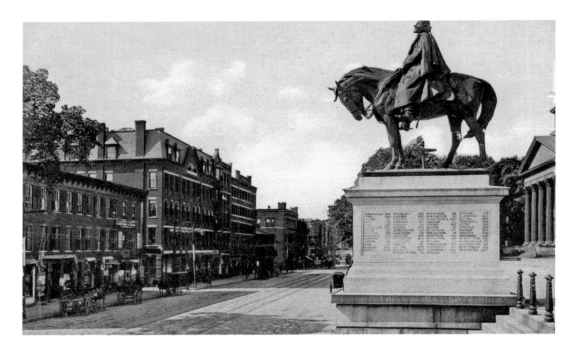

DEVENS STATUE: This 1890s view on Main Street shows the Devens Statue out on the center courthouse steps. Major General Charles Devens moved to Worcester in 1854 at thirty and partnered in the law firm of George Frisbee Hoar. Twice wounded in the Civil War, he later became Attorney General of the U.S. and a Massachusetts Supreme Court Justice. All of the buildings on Main Street to the left in the above view have been razed and the statue moved back.

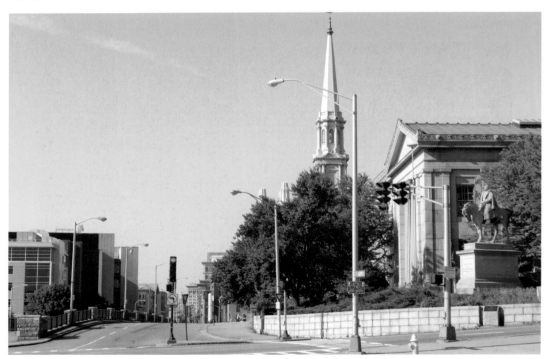

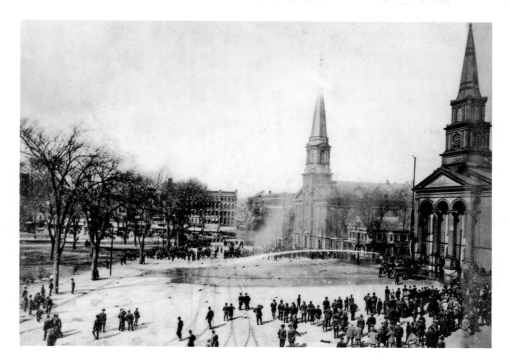

OLD WORCESTER SCENES: A large crowd has gathered to watch the Fire Department display its equipment. If you look closely you can see the spray from the tall hosepipe in front of the Notre Dames des Canadiens Church. This 1890s view also shows the Baptist Church and Front Street with Worcester Common to the left. Below in 1905, a driver poses with his C. T. Sherer delivery wagon with the same background. Becker Business College can be read on the building.

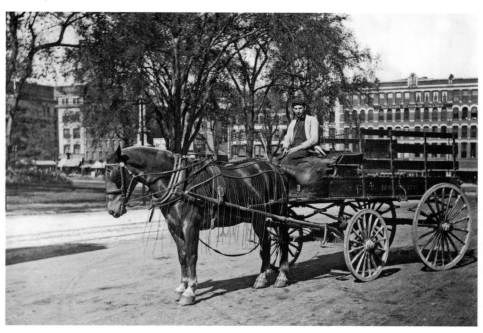

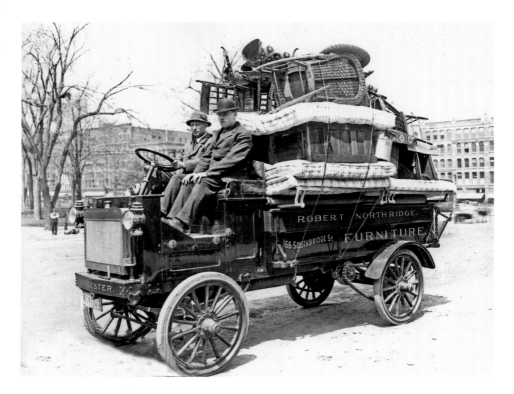

HOW TIMES HAVE CHANGED: Once again from this location two deliverymen pose with their more modern form of transportation for the Robert Northridge Furniture Company of 166 Southbridge Street. The view today is strikingly different. The People's United Bank is on the right and the 100 Front Street Tower (formerly the Mechanics Tower) is in the distance where Becker College once stood.

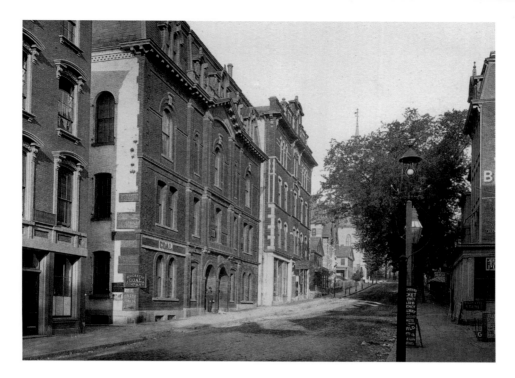

PEARL STREET: Pearl Street was the location of the Masonic Hall, the old Odd Fellows Hall, churches and businesses. Worcester Coal, Han Lee Laundry, George Barnard Slate Roofer and Jeremiah Cahill Plumbing are all identified on signs. Further up the street was the Bull Mansion with its white horizontal stone stripes, later to become the GAR Hall. In the photo below all the buildings have become the GAR Hall. The former Union Church on Chestnut Street, built in 1895-7, faces in the distance. Today it is privately owned.

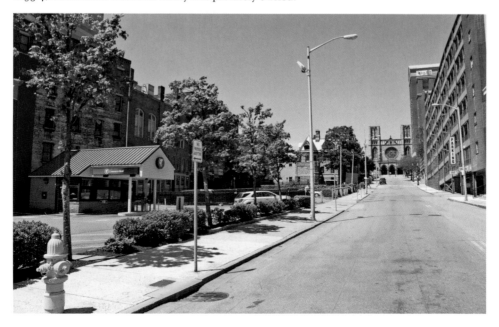

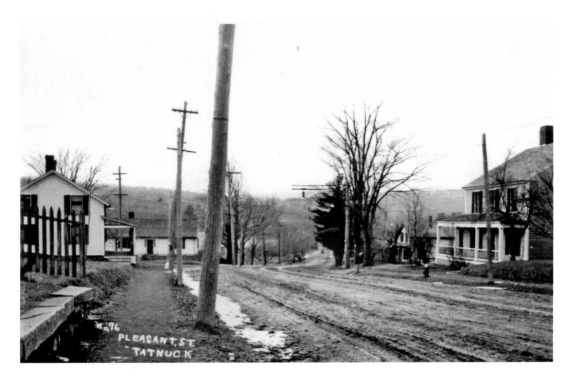

PLEASANT STREET: This *c.* 1888 view of Pleasant Street in Tatnuck is looking west toward Paxton. At this time the area was primarily homes and farms. The photo below shows the almost universal change to commercial use.

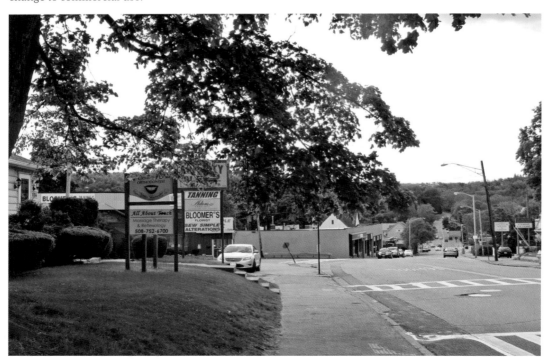

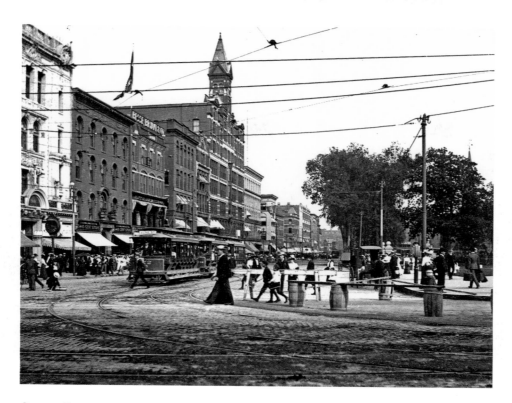

CHASE BLOCK: In the late 1890s Front Street was a focus of trolley and pedestrian activity. The Chase block, designed by R. C. Taylor and built in 1886, is shown with its commanding center tower. Today the tower looks small in comparison to the former Mechanics Tower. In the distance is seen a recently reopened Front Street.

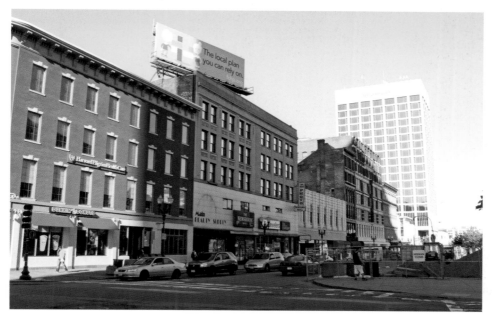

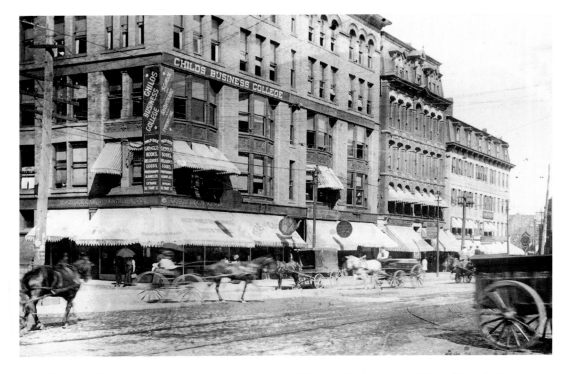

FRONT STREET: Front Street at the corner of Church Street was bustling with activity in the late 1890s. Many businesses such as Rocheleau, Granger Hats & Trunks, The Sherwood House, Importers Tea & Coffee, and Child's Business College were located in this block. In the late 1960s this area from 104 Front Street to 136 Front Street was demolished to make room for Worcester Center Galleria. Today, from 100 Front Street on the left, is a photo of the same area with the street recently reopened and the Galleria razed.

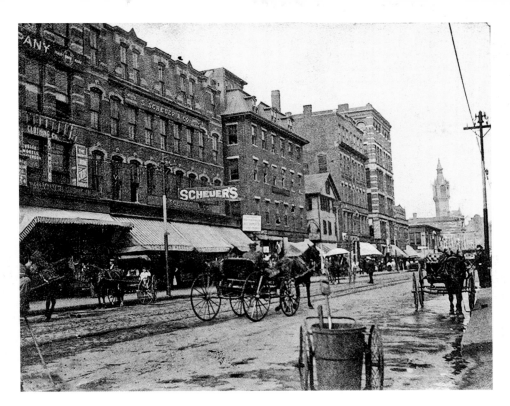

WORCESTER COLLEGE: The Worcester Center urban renewal required the removal of many streets such as Vine, Church, Cherry, Orange, Canal, Foundry, Warren and Bartlett. In the 1890s photo above Scheuer's Grocery Store is at 158 Front Street. The tower of the 1875 Union Station can be seen in the distance. Below the Saint Vincent Cancer Center is approximately in the middle of the above photo. One needs to walk the area with old photos in hand to grasp the change.

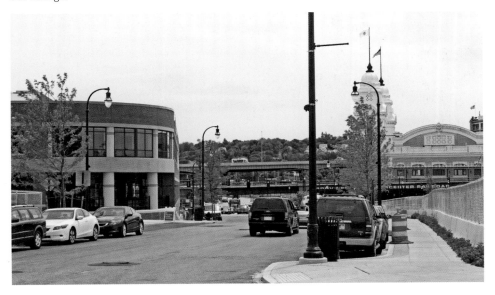

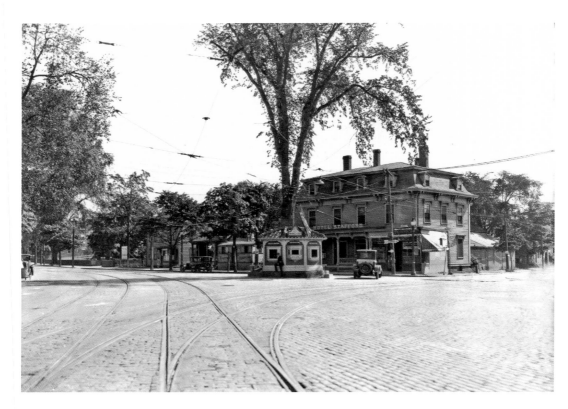

STAFFORD HOUSE: The cobblestones and trolley tracks of the early 1900s are evident in the above view as we look up Main Street at Webster Square. Cambridge Street is on the right and the Stafford House is in the center at 1059 Main Street. The small octagonal building was an information kiosk for the city of Worcester much like what is seen in Boston today. Today the Hotel Stafford stands as Jeremiah's Inn, home to a residential recovery program for men.

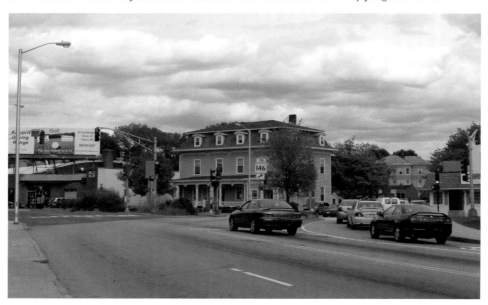

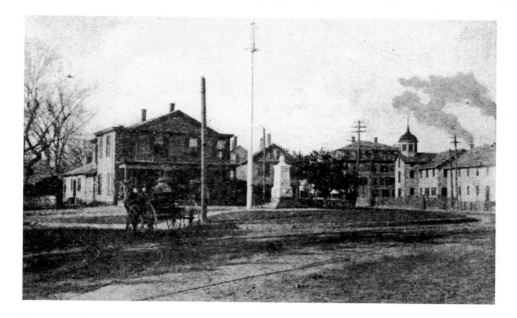

WEBSTER SQUARE: This 1870s view of Webster Square shows a driver in his wagon headed west on Webster Street with Main Street on the right. The area is barely recognizable today. All the buildings are gone with one of the factories on the right now a gas station and the other retail business. The island still remains.

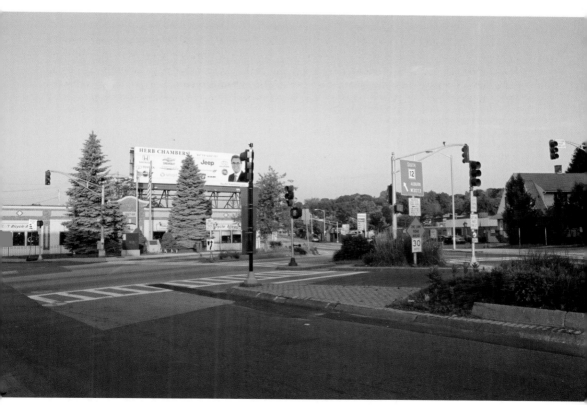

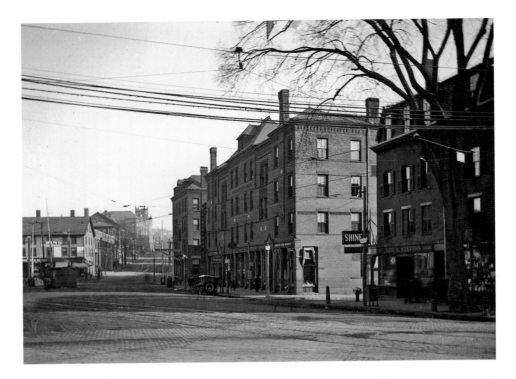

LINCOLN SQUARE: This *c.* 1900 view of Lincoln Square was taken looking up Belmont Street. The square tower of the Belmont Street Baptist Church can be seen in the distance in both photographs with little else remaining. Today the tower of the James P. Lennon apartments and the Worcester Police Station dominate the landscape. The Major Taylor Boulevard runs in front of the station.

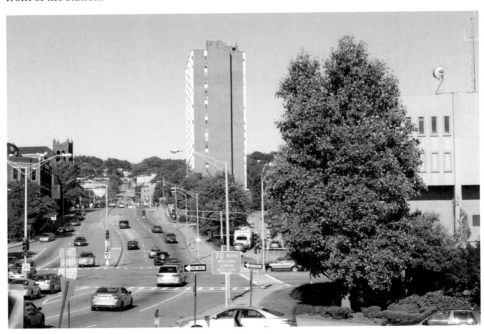

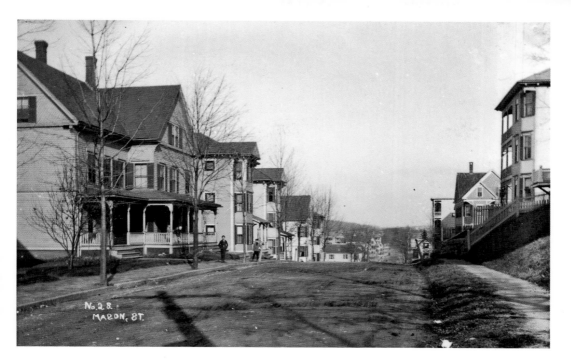

MASON STREET: Mason Street, which runs from May to Chandler was typical of many streets in Worcester in 1900. The prevalence of three deckers running up and down the hills and was a scene for which Worcester was noted. Mason Street runs from May Street to Chandler Street. The view below shows that buildings in the distance have been replaced by non-residential structures such as the blue striped Redemption Christian Center International Church.

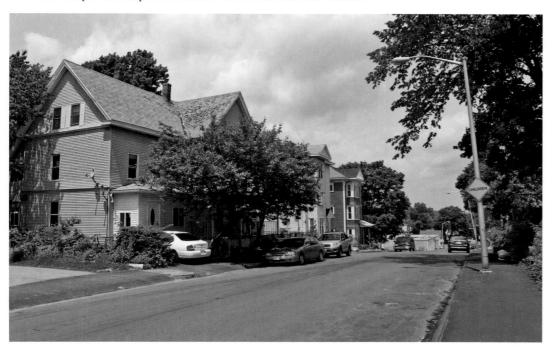

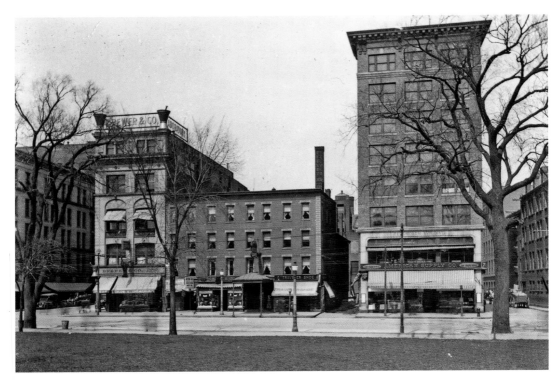

COMMERCIAL STREET: This *c.* 1904 photograph shows the area between Commercial Street on the left and Mercantile Street on the right. The Brewer Drug Building (name on top) was used by a wholesale and retail drug company. American Supply Company on the right was in business for decades as a furniture and household goods dealer. The building of the Worcester Center Galleria in the late 1960s resulted in the demolition of this block. Today the Worcester Registry of Deeds and CVS take up a large portion of the block.

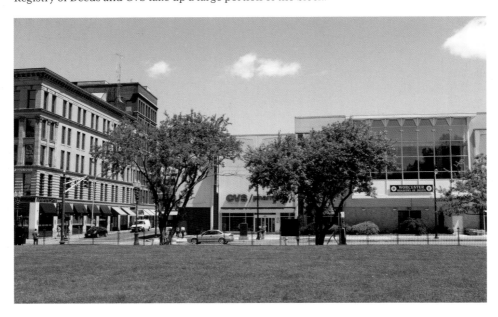

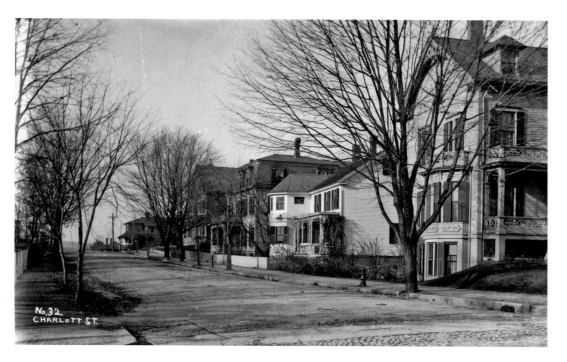

CHARLOTTE STREET: Charlotte Street looks serene on this fall day in 1901. This view was taken from the corner of Woodland Street. Notice that the photographer left off the 'e' in his note scribbled into the negative. Today a few of the homes have been leveled on the right and Clark University has built Esterbrook Hall on the left. Clark has purchased and renovated many beautiful old homes in the area, such as the green one in the foreground below, and uses them for school offices.

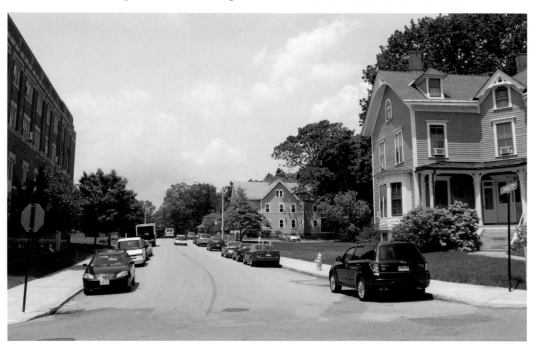

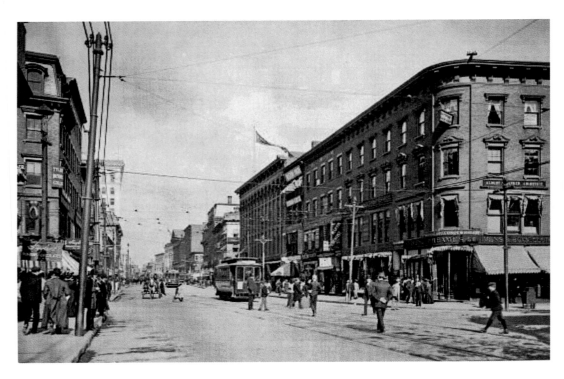

MAIN STREET: Main Street at Harrington Corner was vibrant with pedestrians, buggies and trolleys in this late 1890s scene. In the distance on the left is the newly built State Mutual Life Assurance building. Designed by Peabody & Stearns, this was Worcester's first steel framed 'skyscraper'. As can be seen below on the left the red brick block that was home to the popular Easton's stationary and news-stand store is still standing as is Harrington Corner.

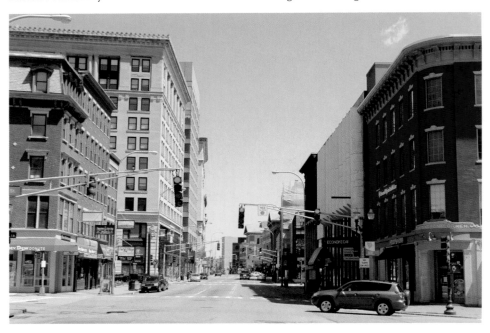

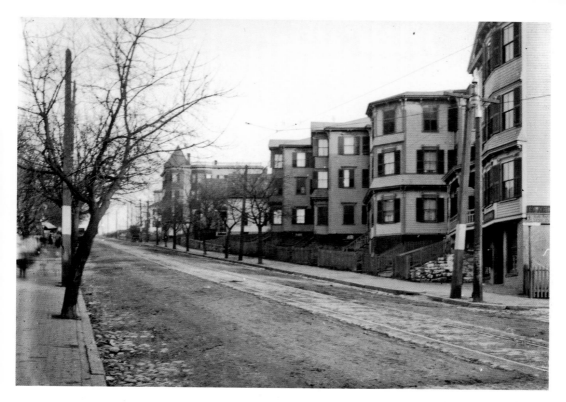

BELMONT STREET HILL: The horses must have worked extra hard pulling wagons up the steep Belmont Street Hill. In this *c.* 1900 photograph the Finlandia Grocery Store was located in the basement of the first house on the right. Today the homes are all still standing and remodeled. On the left, not visible in the photograph below, is the Umass Medical Center.

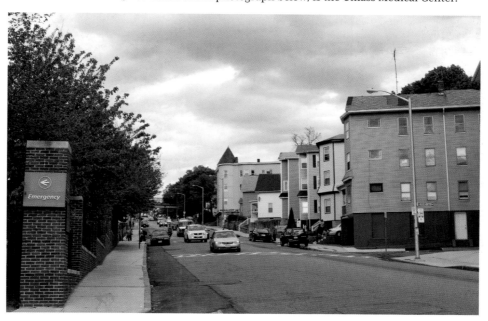

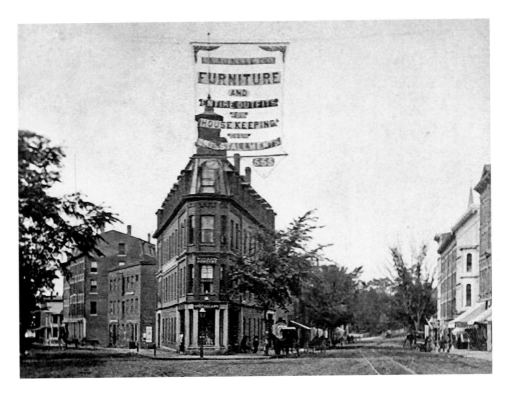

WORCESTER'S: Many cities had 'flatiron' buildings built at triangular intersections. Worcester's was built in 1866 shortly after the Civil War. It was owned by the Scott family and often called the Scott block. Thought by many to be ugly, it was torn down by the city in 1928. The above rare photograph from the 1890s has a banner strung across the street for advertising. The site today is the Federal Plaza Park and is across from the Hanover Theater. The Federal Building, formerly the Post Office, is behind the park.

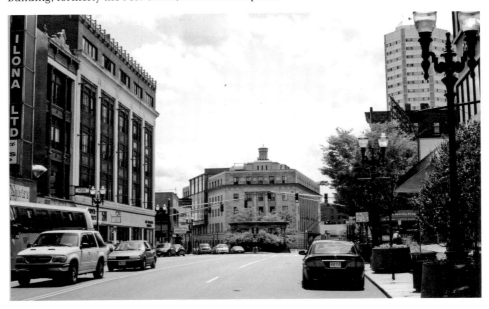

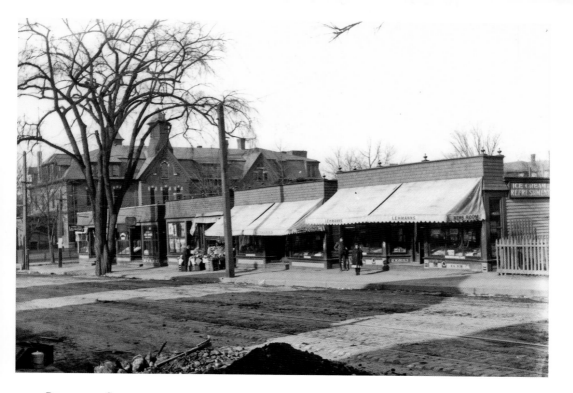

BELMONT STREET: The awnings of George Lehmann's grocery store at 99 Belmont Street stand out in this *c.* 1900 street view. Belmont Street School designed by Earle & Fuller and first occupied in 1871, stands in the distance. The school was used for ninety-nine years, closed, and destroyed by fire in 1972. The blue sign at the corner of Oak Avenue below signifies the site is now occupied by Umass Medical Center.

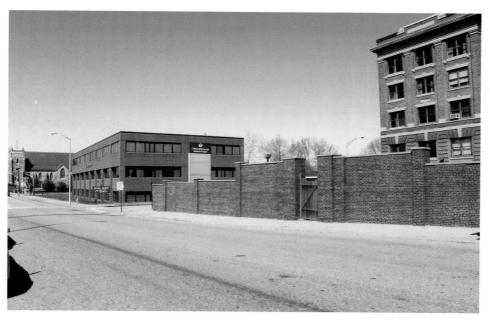

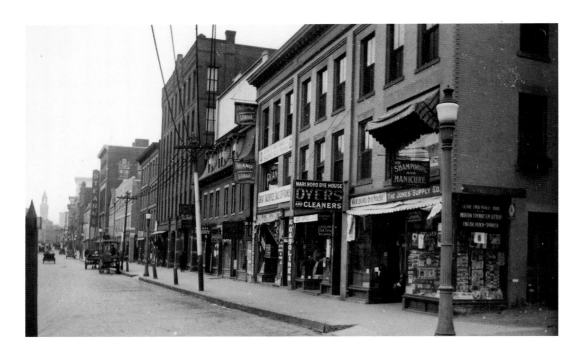

CITY HALL: This early 1900s view of Main Street looking towards City Hall shows a long strip of commercial buildings. The five-story brick Armsby building in the foreground stands next to the famous Elwood Adams four-story block built in 1831. This is the oldest brick commercial block left in the city. Today, three of the first four buildings remain. City Hall can be seen in the distance in both photographs.

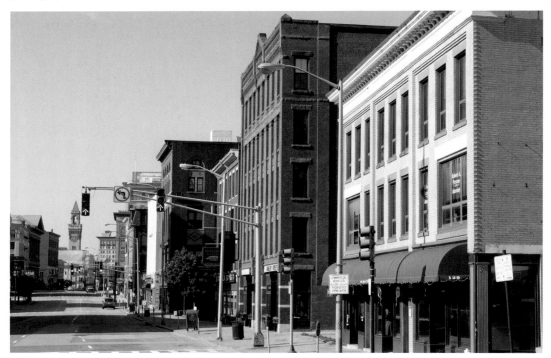

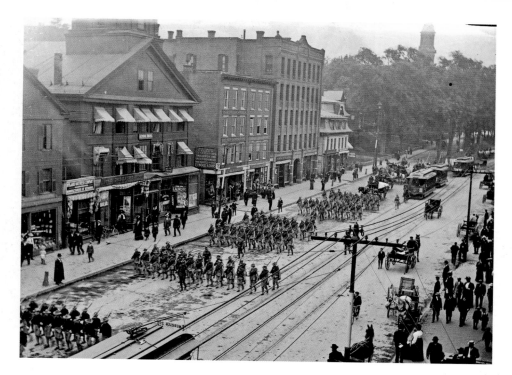

CENTRAL CHURCH: Platoons of soldiers march up a busy Main Street while a line of trolleys, carriages and pedestrians move along side. The old Central Church, now commercially occupied, had its façade completely altered and stands replete with awnings in this *c.* 1898 photograph. An Elwood Adams billboard is on the side of the building next door. The church site is now a parking lot. The towers of the Wesley Methodist and Unitarian Churches are in the background below.

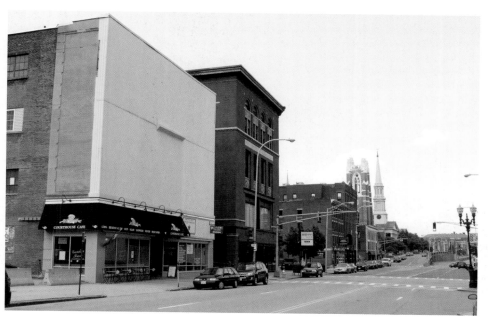

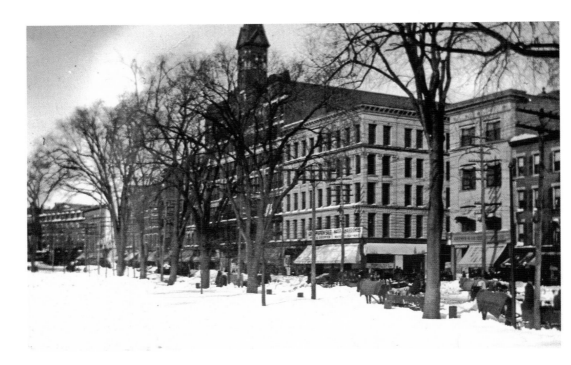

FRONT STREET: This rare *c.* 1900 winter scene of Front Street, looking toward Pleasant Street, shows the edge of the Worcester Common and Front Street blanketed with snow. Notice several sleighs on the street. The area as shown below, has changed dramatically with the tall Sovereign Bank building in the distance and much evidence of razed buildings on Front Street. The streetlights are now electric and not gas.

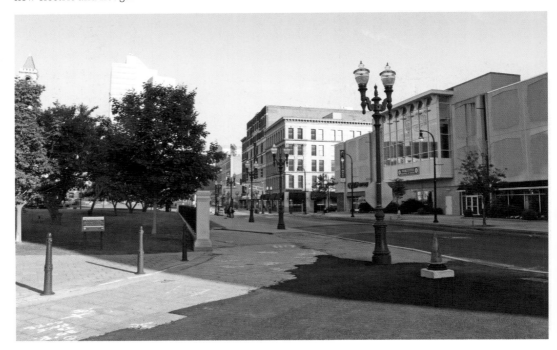

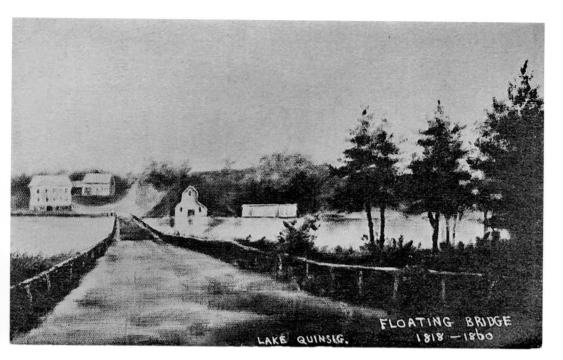

LAKE QUINSIGAMOND: Crossing Lake Quinsigamond on horseback or in a wagon while traversing on top of floating logs surely must have been a harrowing experience. The dated drawing above depicts one of the unsuccessful attempts at floating bridges. Below, looking west toward Worcester in *c.* 1890 a more permanent solution of a solid, filled causeway is seen. It was built in 1862.

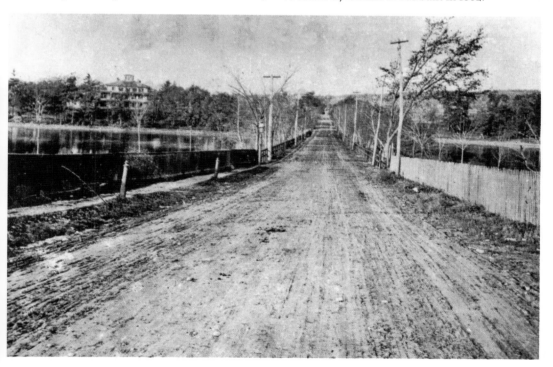

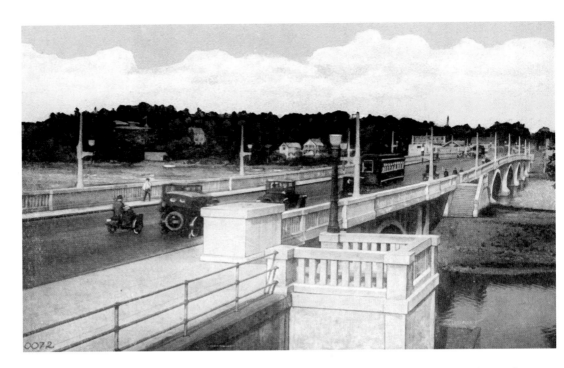

CONCRETE BRIDGES: The concrete bridge shown above was completed in 1919 and was the culmination of many plans and discussions as to how to replace the causeway. Construction is taking place to once again widen the bridge. In the photograph below, looking west toward Worcester, Umass Medical Center can be seen on the hill to the right.

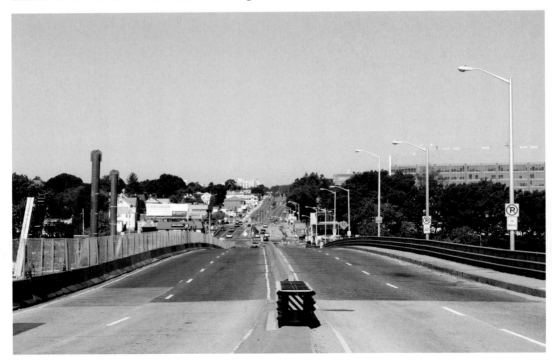

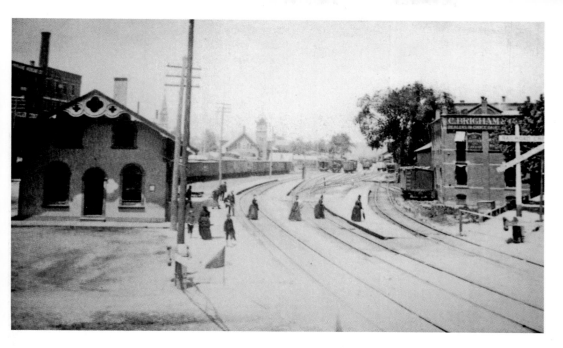

CHANGING TRAFFIC: The Boston and Maine Railroad Station at Lincoln Square is seen to the left in this 1888 picture. A number of women in their long dresses of the period are crossing the tracks. In the distance Lincoln Street bends to the right. C. Brigham Company is on the right at 2 Lincoln Street. The view below shows traffic of a different time and technology. The former Boys' Club is to the left of the train station site.

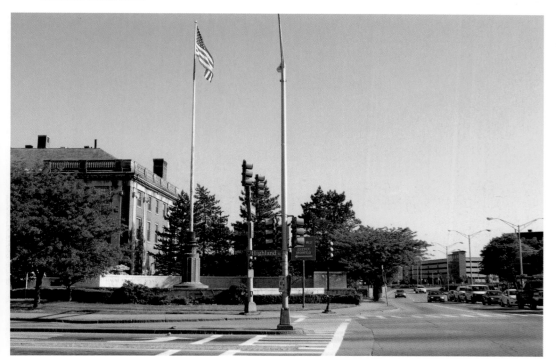

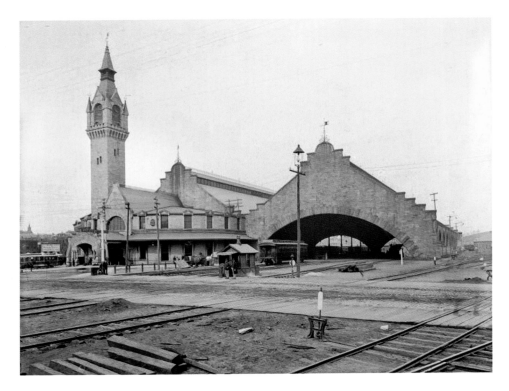

UNION STATION: This *c.* 1900 view of the old Union Station shows its massive arch through which the trains ran. The lions at the base of each side are now at the entrance to East Park on Shrewsbury Street. The station was designed by H. H. Richardson and opened in 1875. The tower and much of the round passenger section remained until removed for Route 290 in 1959. Below the photo was taken from the 1911 Union Station to approximate the same view today.

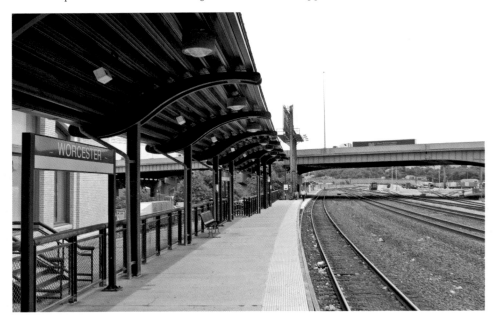

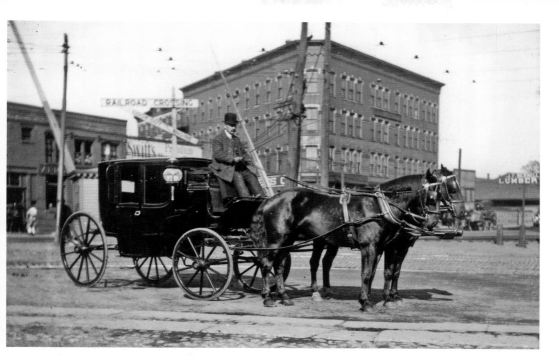

WASHINGTON SQUARE: It is hard to believe that both photographs are looking at the same area. The taxi driver sits in Washington Square with the E. T. Smith block at 26-30 Shrewsbury Street behind him. At the time of this photo in the late 1890s the wholesale grocery company had moved nearby to 203 Summer Street. In the view below the Smith building above would be in the center near the end of Shrewsbury Street just behind the overpass.

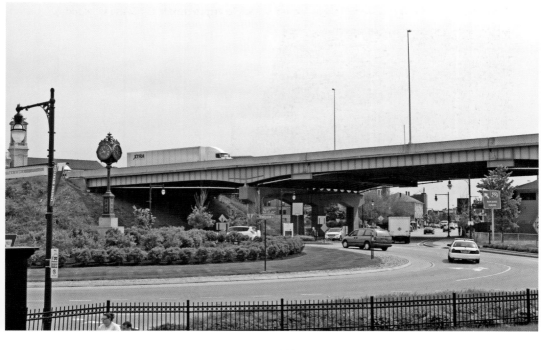

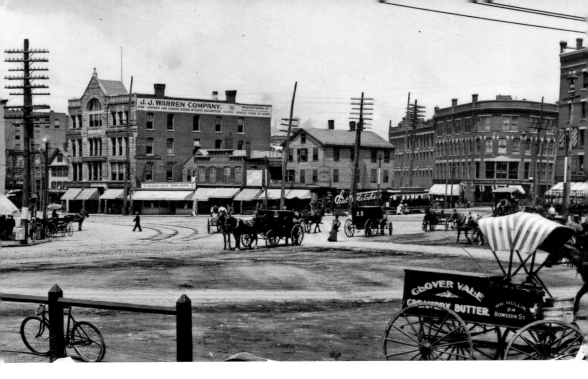

SUMMER STREET: This *c.* 1902 view above shows a hub of commercial activity at Washington Square. J. J. Warren on the left sold leather goods. The round front Hotel Albany, which opened in 1901 and the Darling & Rhodes milk bottle and household goods company are seen far right on each side of Summer Street. The same location today is not recognizable. Summer Street is to the far right and the J. J. Warren Company would be approximately where the cars are parked with St. Vincent's Hospital behind them.

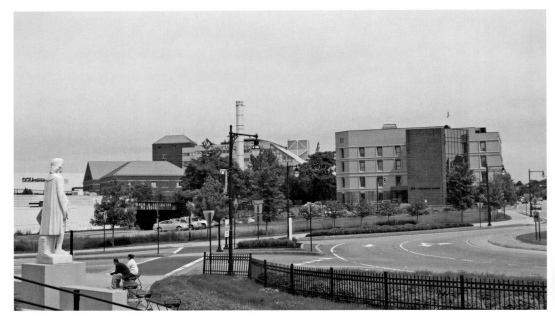